Perfume Bottles

PROFUMI MIGNON

Carla Bordignon

CHRONICLE BOOKS

SAN FRANCISCO

First published in the United States of America by Chronicle Books in 1995.
Copyright © 1986 by BE-MA Editrice.

Printed in Hong Kong.

Library of Congress Cataloging-in-Publication Data:
Bordignon, Carla.
 [Profumi mignon. English]
 Perfume Bottles = Profumi mignon/Carla Bordignon
 [caption translation, Joe McClinton].
 p. cm.— (Bella cosa library)
 ISBN 0-8118-1061-5 (pb)
 1. Miniature perfume bottles I. Title II. Series: Bella Cosa.
 NK8475.P47B6713 1995
 748.8'2'0228—dc20 94-45122
 CIP

Caption translation: Joe McClinton
Photography: Antonio Fedeli
Series design: Dana Shields, CKS Partners, Inc.
Design/Production: Robin Whiteside

Distributed in Canada by Raincoast Books
8680 Cambie Street
Vancouver, B.C. V6P 6M9

10 9 8 7 6 5 4 3 2 1

Chronicle Books
275 Fifth Street
San Francisco, California 94103

Perfume Bottles

*S*ince ancient times, perfumes have been kept in beautiful and often precious containers of many different shapes and materials. Collecting perfume boxes and vials, flasks and bottles was not uncommon in the nineteenth century, but this hobby became enormously popular in Europe and the United States in the 1970s. This is not surprising; anyone who takes home one of these bottles, whether large or small, will feel the lure of new, different, and always fascinating designs. Besides its intrinsic aesthetic satisfaction, collecting perfume bottles also fosters a better understanding of the history of fashion as the design of a bottle is always a kind of summation of the taste of its era.

Our selection includes more than a hundred bottles of the most famous perfumes in the world, dating from the late 1920s to the present.

\mathcal{V}ioletta di Parma is one of the oldest of the modern Italian perfumes, and is still produced by Borsari. The friars at the Monastery dell'Annunziata created it early in the nineteenth century for Marie-Louise of Austria, Duchess of Parma; Borsari acquired it later. The photo shows two flasks from different periods, and a purse spray.

Violetta di Parma è uno fra i più antichi profumi italiani moderni, prodotto ancor oggi dalla Borsari. Fu creato per Maria Luigia d'Austria Duchessa di Parma nella prima metà dell''800 dai frati del convento dell'Annunziata e poi acquisito dalla Borsari. Nella foto, due flaconi di epoche diverse e uno spray da borsetta.

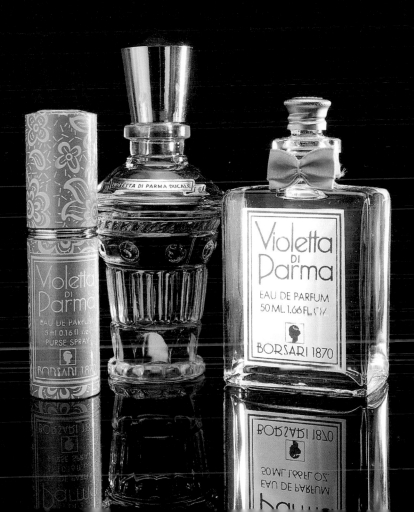

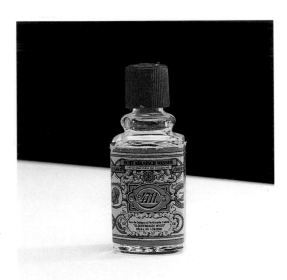

\mathscr{A} miniature bottle of
Eau de Cologne 4711, first
sold in Cologne, Germany,
in 1709. The label has
remained unchanged since
then.

*La boccetta mignon
dell'Acqua di Colonia 4711,
messa in commercio per la
prima volta a Colonia, in
Germania, nel 1709. Da
quel tempo anche l'etichetta
è rimasta sempre la stessa.*

*J*oy, by Patou, was launched in 1935 as the most expensive perfume in the world. The beautiful classic bottle is by Louis Süe.

Joy di Patou è il profumo lanciato come il più caro del mondo nel 1935. Bellissimo il flacone di linea classica, di Louis Süe.

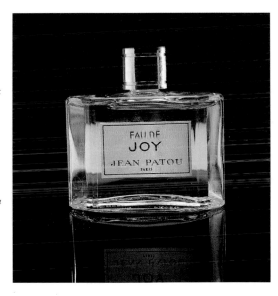

\mathcal{A}nother very beautiful classic: a 1933 bottle for Fleurs de Rocaille, by Caron, designed by Michel Morsetti. A golden bow is tied around the top.

Un altro "classico" di grande bellezza: flacone per Fleurs de Rocaille di Caron che risale al 1933, disegnato da Michel Morsetti. Attorno al tappo era legato un fiocchetto dorato. ➤

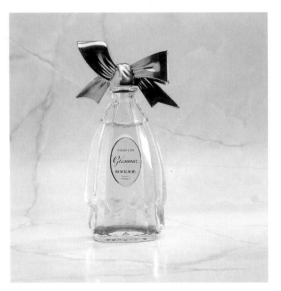

\mathcal{T}his slim bottle, designed for Bourjois's Glamour, is decidedly romantic, with a golden metal bow on the top.

Di stile decisamente romantico questo flacone slanciato ideato per Glamour di Bourjois, caratterizzato dal tappo in metallo dorato che ha la forma di un fiocco.

◄

\mathcal{A} sumptuous bottle for Lys Bleu. Miniature bottles like this one, perfect reproductions of their full-sized counterparts, are expensive and much sought after by collectors.

Boccetta decisamente sontuosa che contiene il profumo Lys Bleu. I mignon di questo tipo, perfetta riproduzione dei flaconi grandi, sono costosi e molto ricercati dai collezionisti. ➤

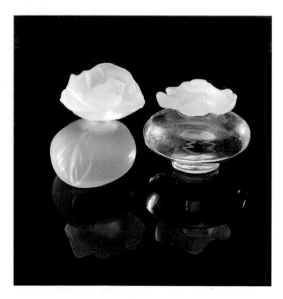

\mathcal{T}he two miniature bottles in the photograph both feature rounded lines and dramatic tops. One contains Kenzo, by the Japanese couturier of the same name, and the other was designed by Lalique for Nina Ricci.

I due mignon della foto sono fra loro accomunati dalla linea rotondeggiante e dal tappo importante. Uno racchiude il profumo Kenzo, dell'omonimo sarto giapponese, l'altro il profumo Nina Ricci, ed è stato realizzato da Lalique. ◄

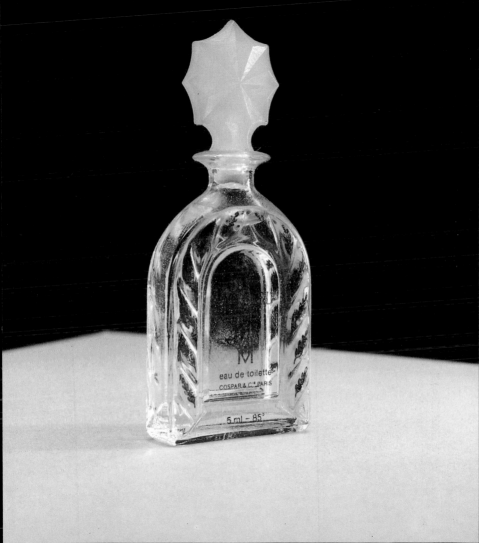

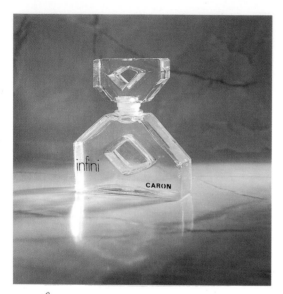

\mathcal{I}nfini, by Caron, is a floral-green perfume that has been in production since 1970. Its highly sophisticated bottle was designed by Serge Mansau, one of the most respected designers in the field.

Infini di Caron è un profumo di tipo fiorito-verde prodotto dal 1970; il suo flacone, di rara raffinatezza, è di Serge Mansau, uno dei più apprezzati designer del settore.

\mathcal{L}umière, by Rochas, dating from 1984, is a very special blend in an iridescent bottle in shades of sapphire and amethyst. The top is faceted like a diamond.

E' del 1984 Lumière di Rochas, una miscela molto speciale racchiusa in un flacone iridescente giocato sui toni dello zaffiro e dell'ametista. Il tappo ha il lato esterno intagliato come un diamante.

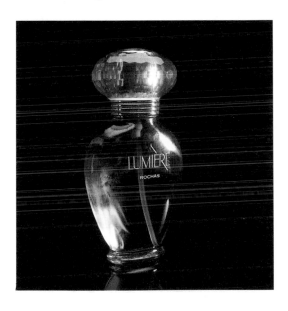

Sogni Miei by Satinine dates to the 1930s. A tiny booklet with a romantic poem printed inside, just like the one here, accompanied each bottle.

Risale agli anni '30 Sogni Miei di Satinine. Come si può vedere, ogni flacone era accompagnato da un libricino di dimensioni minuscole nel quale era stampata una poesia romantica. ➤

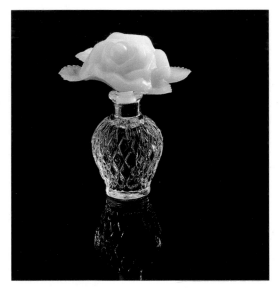

Even in miniature, this bottle, topped with a delicate pink rose, loses none of its refined grace.

Anche nella versione mignon non ha perso nulla della sua preziosa grazia questo flacone dominato dal tappo a forma di rosa delicatamente rosea.
◄

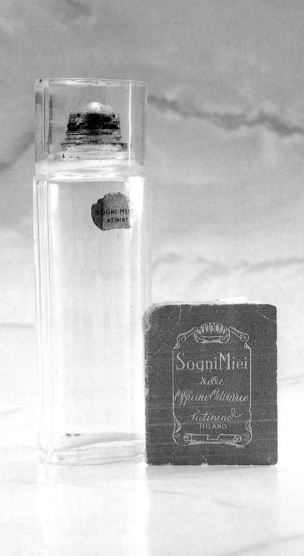

*W*hen Arpège was launched by Lanvin in 1927, it became one of the most popular perfumes for elegant women, and is still a favorite. The photograph shows three bottles from different periods.

Facciamo un salto all'indietro e precisamente nel 1927, anno in cui fu lanciato Arpège di Lanvin, uno dei profumi più apprezzati dalle donne eleganti e mai dimenticato. Nella foto, tre flaconi di epoche diverse. ➤

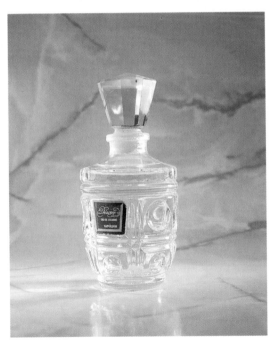

*T*his bottle, embellished with elaborate relief work and topped with a large stopper, was made for the perfume Désirée, by Napoleon. Désirée was the name of the first fiancée of the future emperor Napoleon Bonaparte.

Flacone arricchito da una lavorazione elaborata, dominato da un tappo importante; è stato studiato per il profumo Désirée di Napoleon. Si chiamava Désirée la prima fidanzata del futuro imperatore Napoleon Bonaparte. ◄

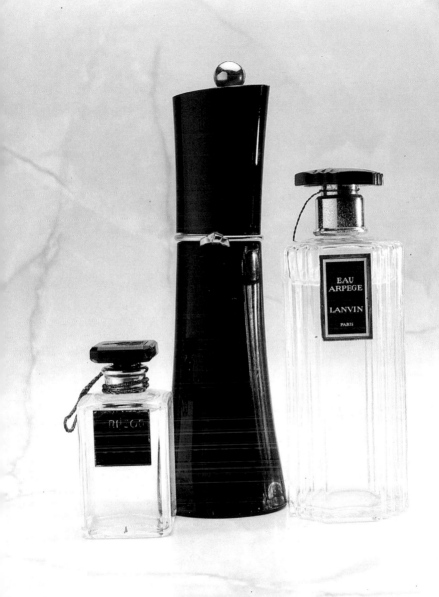

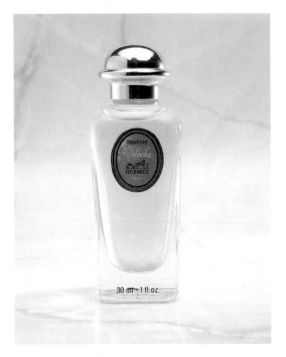

30 ml - 1 fl.oz.

\mathcal{A}nother great classic from the past: Calèche, by Hermès, in a smart bottle designed by Joël Desgrippes in 1961, the year the perfume was launched. It was an immediate success.

Questo è un altro grande "classico" del passato: Calèche di Hermès racchiuso in un raffinato flacone ideato da Joël Desgrippes nel 1961, anno del lancio sul mercato. Fu subito un successo.

Another immediate hit was Cabochard, by Grès, presented in an exquisite bottle that loses none of its beauty in miniature. This bottle dates from 1959.

E fu subito un successo anche Cabochard di Grès, presentato in una bottiglia preziosa che non ha perso nulla della sua bellezza nemmeno in versione mignon. E' del 1959.

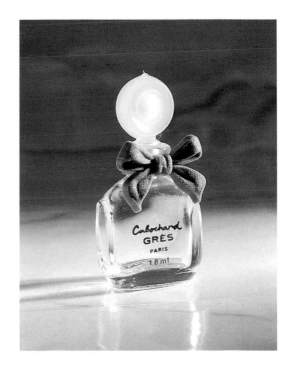

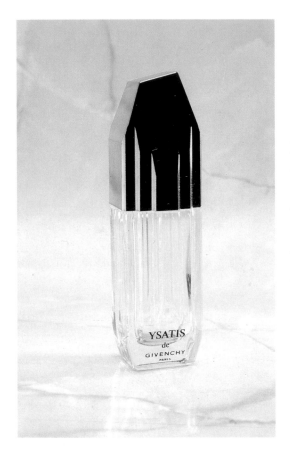

*H*ubert de Givenchy, respected French couturier, was famed for dressing Audrey Hepburn. Ysatis is one of his most successful perfumes from the 1980s. The bottle is by Pierre Dinand.

Hubert de Givenchy è un altro famoso sarto francese, noto a suo tempo anche per aver vestito Audrey Hepburn. Ysatis è uno dei suoi profumi più fortunati degli anni '80. Il flacone è firmato da Pierre Dinand.

A selection, in miniature, of some of the perfumes from Coco Chanel, the most famous of the great French couturiers of the past. Though they contain different perfumes, the tiny bottles all share the same classic simplicity.

Questo è un piccolo campionario, in formato ridotto, di parte della produzione di profumi firmati da Coco Chanel, la più famosa fra le grandi sarte parigine del passato. I profumi cambiano nome e fragranza, ma i piccoli contenitori sono simili, di classica semplicità.

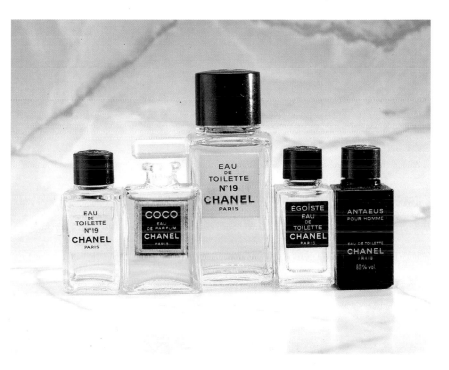

𝒯his wonderful bottle, with its top shaped like a bird spreading its wings, is from Nina Ricci. This house has always devoted great care to the aesthetic presentation of its various fragrances.

E' di Nina Ricci il prezioso flacone caratterizzato dal tappo a forma d'uccello con le ali spiegate. Fin dagli inizi questa casa ha sempre molto curato la presentazione estetica delle diverse fragranze. ➤

𝒮cents by Rochas, in bottles of different shapes to suit their contents. From the left, Macassar, Lumière, Madame Rochas, and Monsieur Rochas.

Introduced between 1960 and 1980, these perfumes are today enjoying a comeback.

Qui invece siamo in casa Rochas e le forme dei contenitori cambiano per meglio adattarsi al contenuto. Da sinistra, Macassar, Lumière, Madame Rochas, Monsieur Rochas. Sono stati prodotti fra il 1960 e l'80; ed ora vivono una nuova giovinezza. ◄

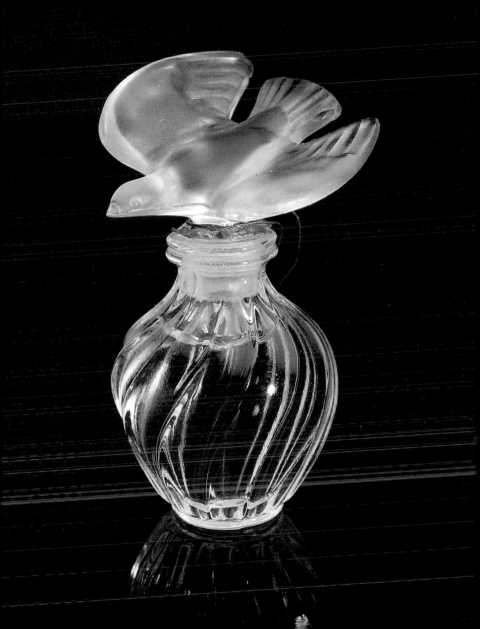

Xeryus, Eau de Givenchy, Ysatis, and Givenchy Gentleman: a group of miniatures from Givenchy. The different styles hold four very different fragrances.

Xeryus, Eau de Givenchy, Ysatis e Givenchy Gentleman: ecco i nomi dei profumi del sarto Givenchy contenuti nelle boccette mignon riunite nella foto; quattro stili diversi per frangranze diversissime fra loro. ➤

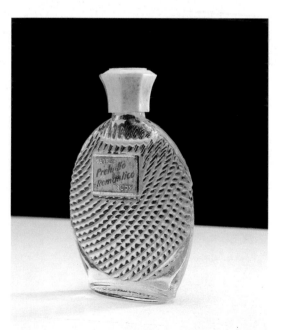

This elegant miniature is a perfectly detailed reproduction of the full-sized faceted bottle created for Preludio Romantico, an Italian perfume.

Semplice, nella sua eleganza, la mignon che riproduce perfettamente fin nei dettagli la bottiglia sfaccettata creata per Preludio Romantico, un profumo di produzione italiana.
◄

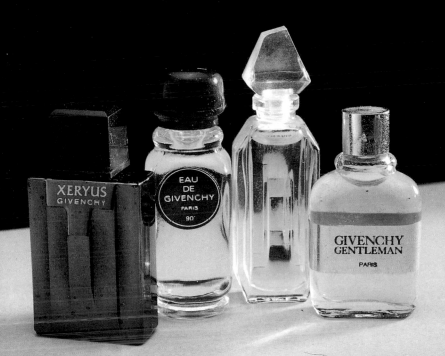

\mathcal{T}hese bottles for perfumes from different houses are all similar in their stylishness, charm, and elegance. Their beauty is not diminished in the least by their small size.

Sono accomunate da stile, grazia ed eleganza queste tre boccette studiate per altrettanti profumi di case diverse. Le misure ridottissime non ne hanno diminuito la bellezza.

\mathcal{I}n 1966, the house of Guy Laroche commissioned Serge Mansau to design a very special bottle for the perfume Fidji. The result, as seen here, is so perfect that no further comment is necessary.

Serge Mansau nel 1966 fu incaricato della casa Guy Laroche di ideare un flacone molto particolare per il profumo Fidji. Il risultato dei suoi studi, che vediamo in questa immagine, è talmente perfetto da non aver bisogno di alcun commento.

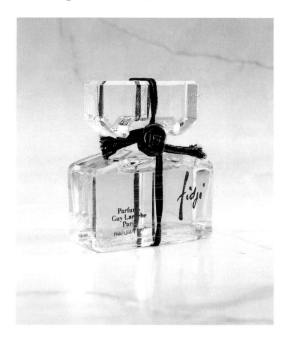

\mathscr{F}emme, a fruity non-alcohol-based scent, was launched by Rochas in 1945. The bottle, by Lalique, has a classic inverted amphora shape, topped with an elegant capital. The case for this miniature is printed with a lacelike pattern.

Femme è un profumo ciprato-fruttato messo in vendita da Rochas nel 1945. Il flacone ha le forme classiche di un'anfora rovesciata sormontata da un prezioso capitello. L'astuccio, in questa versione mignon, sembra foderato di pizzo. Il flacone è di Lalique. ➤

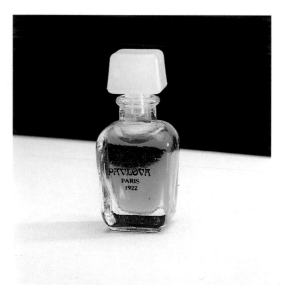

\mathscr{P}avlova: an exclusive perfume with a glorious history. It was created in 1922 when the dance stages of the world were ruled by the extraordinary Russian ballerina, Anna Pavlova.

Pavlova: un profumo di classe che ha una sua gloriosa storia alle spalle in quanto fu creato nel 1922 quando sui palcoscenici di tutto il mondo furoreggiava una straordinaria danzatrice russa che si chiamava Anna Pavlova.
➤

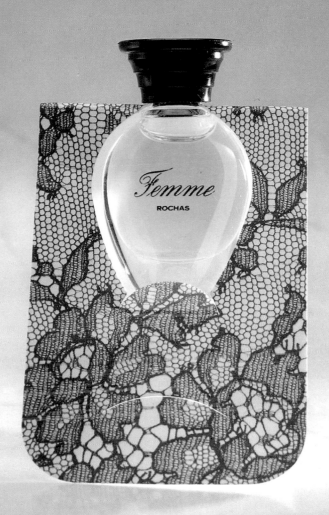

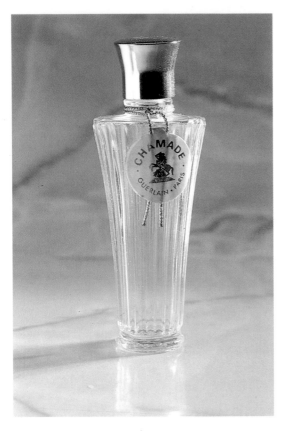

Chamade, by Guerlain, is another of the great French classics, created by Jean Paul Guerlain himself and launched in 1969. This is the miniature version of the bottle, less elaborate than the original design by Robert Granai.

Chamade di Guerlain è un altro dei grandissimi "classici" francesi, creato personalmente da Jean Paul Guerlain e lanciato nel 1969. Qui vediamo la versione mignon del flacone, meno sontuosa di quella ideata da Robert Granai.

\mathcal{T}his miniature is identical to the full-sized bottle for L'Air du Temps, launched by the famous French couturier Nina Ricci in 1947. The bottle is a true glass sculpture by Lalique. The top is crowned with two doves in flight, meeting in a loving caress.

Identico al flacone di misura normale è invece questo che vediamo, che racchiude il profumo L'Air du Temps lanciato da Nina Ricci, la famosa sarta francese, nel lontano 1947. Il flacone è una vera e propria scultura in vetro di Lalique. Il tappo è sovrastato da due colombe in volo che si toccano in gesto d'amore.

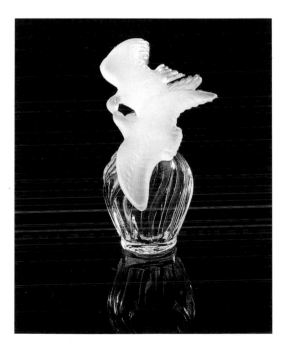

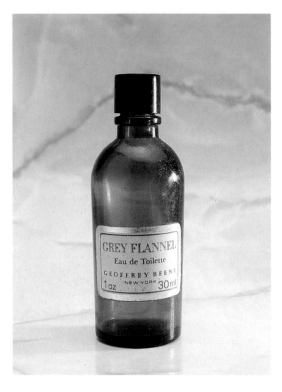

*T*his curious bottle is reminiscent of those used in old-fashioned pharmacies. It was designed for Geoffrey Beene's scent, Grey Flannel.

Curioso questo contenitore che ricorda le bottiglie utilizzate dai farmacisti di un tempo. E' stato ideato per il profumo Grey Flannel di Geoffrey Beene di New York. ≺

A spiral-shaped bottle, splendid even in miniature, created for Montana's 1988 women's perfume. The designer is Serge Mansau.

Ha la forma della spirale il flacone, splendido anche nella versione ridotta, del profumo femminile di Montana del 1988. Il designer è ancora una volta Serge Mansau. ≻

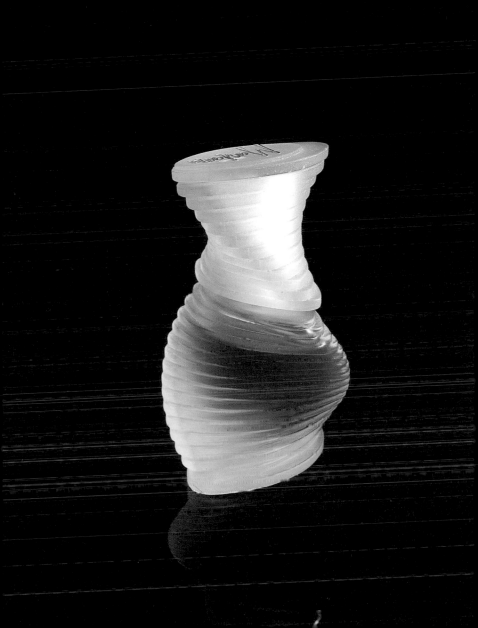

This photograph takes us to another part of the world—to Japan—where, in 1965, Shiseido launched a sophisticated, spicy-floral scent called Zen. The bottle is a unique example of an entirely oriental elegance.

Con questa immagine ci spostiamo all'altra parte del mondo e precisamente in Giappone, dove nel 1965 Shiseido lanciò Zen, un fiorito speziato di classe, presentato in questo flacone, unico nel suo genere per eleganza tutta orientale.

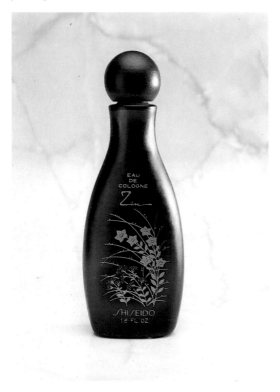

\mathcal{A} sophisticated, oriental-style bottle of intense, luminous China blue was created for Bleu de Chine, a fragrance by Marc de la Morandière. The bottle was designed by Serge Mansau in 1987.

Si chiama Bleu de Chine ed è prodotta da Marc de la Morandière la fragranza contenuta in questa raffinata boccetta orientaleggiante di un intenso e luminoso blu Cina. E' opera di Serge Mansau ed è del 1987.

*I*n the 1960s, well-known French couturier Yves Saint Laurent made his brilliant debut in the world of fine perfumes. This photograph shows miniatures of some of his famous fragrances: Yves Saint Laurent Pour Homme, Y, Rive Gauche, and Opium (in two versions), all launched between 1964 and 1977.

Yves Saint Laurent è uno stilista francese che non ha certo bisogno di presentazione. A partire dagli anni '60 è entrato prepotentemente anche nel mondo dell'alta profumeria riscuotendo grandissimo successo. Nell'immagine, le boccette mignon di alcuni suoi famosi profumi: Yves Saint Laurent Pour Homme, Y, Rive Gauche, Opium (in due versioni), lanciati fra il 1964 e il 1977.

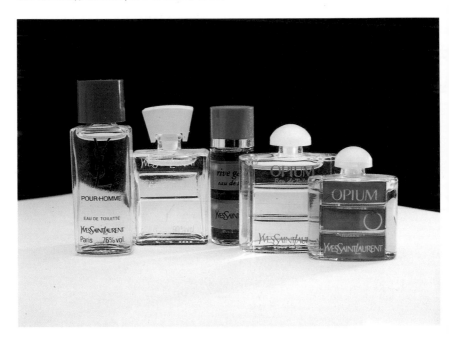

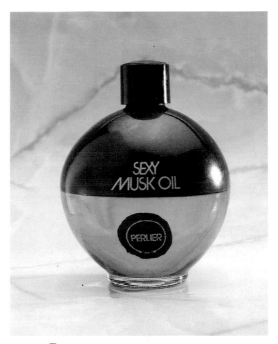

Sexy Musk Oil, by Perlier: a perfume that disappeared from the market years ago, making its beautiful, two-colored, perfectly round bottle quite rare.

Sexy Musk Oil di Perlier: un profumo che da anni non è più in vendita, così come è rara la bellissima boccetta bicolore perfettamente rotonda.

\mathcal{T}he perfume called Irene II came in a bottle as elegant and sophisticated as the lady who commissioned it, the Russian-born couturier Irene Galitzine.

Si chiamava Irene II il profumo che era contenuto in questo flacone elegante e raffinato come la donna che lo volle per il suo profumo: la sarta di origine russa Irene Galitzine.

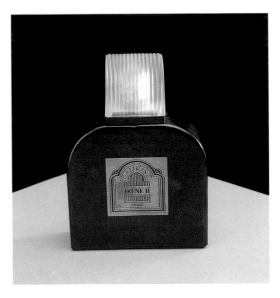

These could be called the "magnificent five" of Hermès: from the left, Eau de Cologne, Amazone, Bel Ami, Equipage, and Parfum d'Hermès. Internationally successful products for an exclusive clientele, these scents were introduced between 1970 and 1986. The miniature bottles are much sought after by collectors.

Potremmo definirli "i magnifici cinque" di Hermès: sono, da sinistra, la Eau de Cologne, Amazone, Bel Ami, Equipage, Parfum d'Hermès: grandi successi internazionali per consumatori di classe. Sono stati messi in vendita fra il 1970 e il 1986. Le boccette mignon sono ambite dai collezionisti.

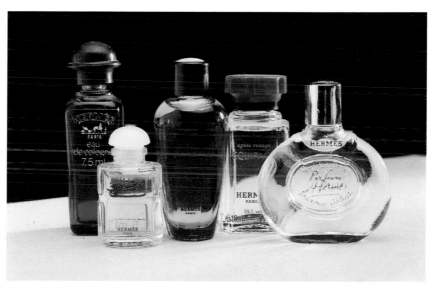

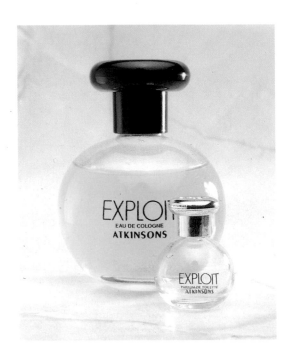

*E*xploit is another fragrance no longer on the market. Made by Atkinsons, it came in an attractive bottle that is shown here in two sizes.

Exploit è un'altra fragranza che non è più in commercio. Era una produzione Atkinsons presentata nel simpatico flacone che vediamo in due diverse misure.

Shown here is Bizarre, also by Atkinsons: the same perfume in three somewhat similar bottles. The one on the right is the oldest, designed by Serge Mansau in 1979. The one in the center is a spray bottle.

Ed ecco Bizarre, sempre di Atkinsons: un unico profumo con tre flaconi che si assomigliano vagamente. Quello a destra nella foto è il più vecchio, firmato da Serge Mansau nel 1979; al centro una confezione spray.

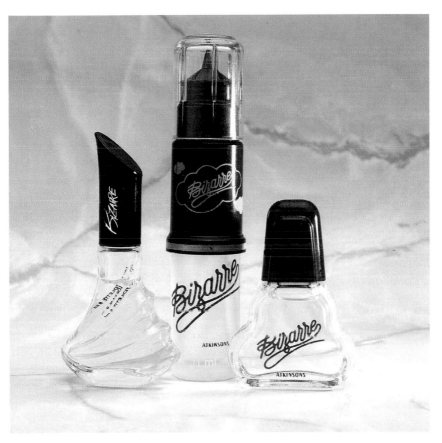

These Atkinsons miniatures are shown with their tin cases; the scents are Rockford and English Lavender.

Torniamo in casa Atkinsons con questi mignon presentati coi loro astucci in lattina: i profumi sono Rockford e English Lavender. ➤

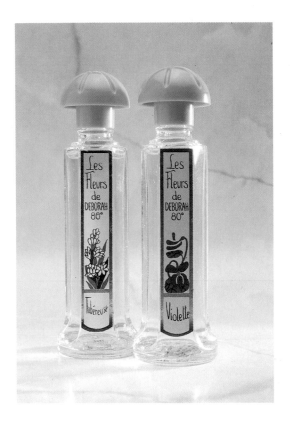

Les Fleurs de Deborah were fresh, floral fragrances much favored by romantic young women. They have recently reappeared on the market in a very similar version.

Si chiamavano Les Fleurs de Deborah ed erano fragranze fresche, fiorite, assai gradite a consumatrici giovani e romantiche. Recentemente sono tornate sul mercato in una versione assai simile.
◄

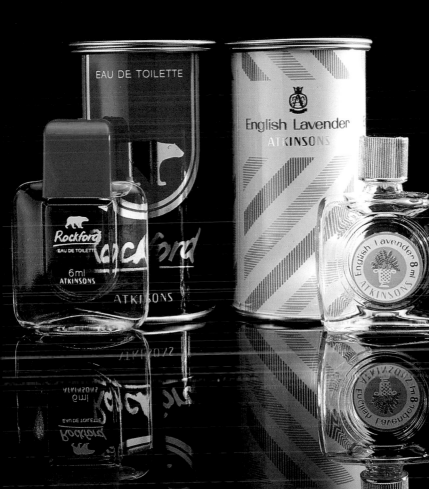

\mathcal{D}edicated to and named after the La Scala opera house, this spicy, semi-oriental scent by Krizia was introduced in 1986. Note the elegance of the miniature and spray bottles.

E' stato dedicato al Teatro alla Scala di cui porta il nome questo profumo di Krizia del 1986. Si tratta di un semi-orientale speziato. Notare la classe della boccetta mignon e della confezione spray. ➤

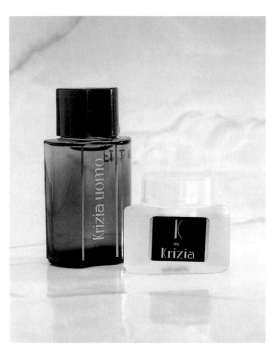

\mathcal{K} and Krizia Uomo are two fairly recent fragrances that have won immediate success with an exclusive clientele. Dating from 1980 and 1983, the bottles were designed by Dinand.

K e Krizia Uomo sono due profumi abbastanza recenti che hanno riscosso molto successo fin dal loro apparire fra le persone di classe. Sono del 1980 e del 1983 e i flaconi sono stati disegnati da Dinand.
◄

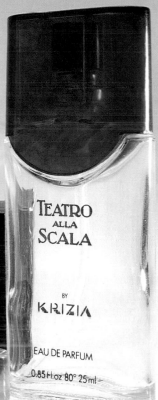
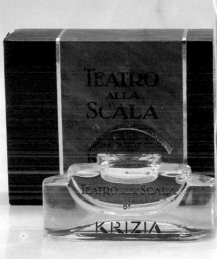

\mathcal{I}n miniature, here are two of the latest fragrances from Mariuccia Mandelli, better known as Krizia: Moods and Moods Uomo, both introduced in 1988. The bottles were designed by Dinand.

Sia pure in versione mignon, ecco come sono presentate le due ultime novità di Mariuccia Mandelli, in arte Krizia. Sono Moods e Moods Uomo, entrambi del 1988. Designer del flacone è Dinand. ➤

\mathcal{T}his unusual metallic bottle was created for Empreinte by the French couturier Courrèges, once famous for designing women's clothes that were made partly of metal.

E' di linea molto particolare e metallizzato il flacone per Empreinte del sarto francese Courrèges, famoso un tempo per i suoi abiti femminili in parte di metallo.
◄

\mathcal{T}his truly unique bottle, commissioned by Marc de la Morandière for his men's scent Gengis Khan in 1990, was designed by Serge Mansau.

Davvero unico questo flacone voluto da Marc de la Morandière per il maschile Gengis Khan del 1990. Ha realizzato la bottiglia Serge Mansau.

≺

\mathcal{C}hristian Dior is another of the great French couturiers who initiated his own line of scents for men and women, beginning with Miss Dior in 1947. The photograph shows Poison, Diorissimo, Eau Sauvage, and Fahrenheit, all fragrances of the greatest distinction.

Christian Dior è un altro dei grandissimi sarti francesi che ha voluto una propria linea di profumi per uomo e per donna fin dal 1947 quando lanciò il primo: Miss Dior. Nella foto, le boccette di Poison, Diorissimo, Eau Sauvage e Fahrenheit, fragranze di gran classe. ➢

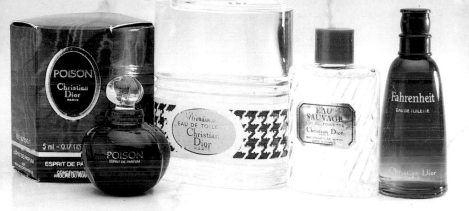

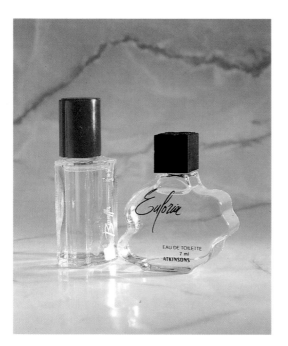

\mathcal{T}wo different bottles for fragrances from the same house. On the right is Euforia, by Atkinsons, introduced in 1985. A delicious floral fantasy, it aspires to be a state of mind rather than just a scent. The bottle is by Serge Mansau.

Due flaconi diversi per un'unica casa di mode. A destra, Euforia di Atkinsons del 1985. Una fantasia deliziosa di fiori che vuol essere quasi uno stato d'animo, più che una fragranza. Il flacone è di Serge Mansau.

\mathcal{B}aruffa, a lively fruity-floral perfume, was launched in 1981 by Atkinsons. Shown here are the purse spray, in a mock cigarette lighter, and a miniature bottle with simple lines.

Si chiama Baruffa, è un allegro profumo di Atkinsons fiorito-fruttato lanciato nel 1981. Qui vediamo la presentazione in confezione spray da borsetta che sembra un accendino e una boccetta mignon di linea semplice.

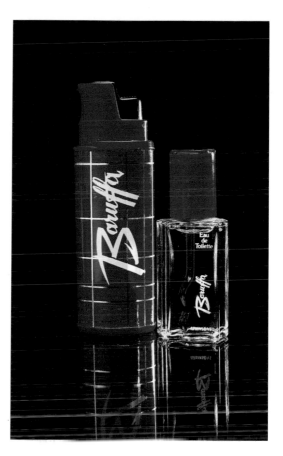

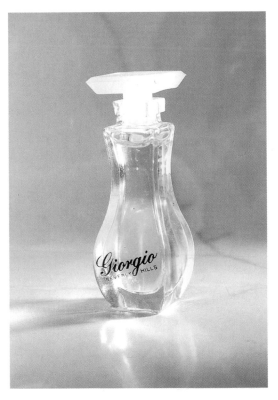

\mathcal{T}he women's version
of Giorgio is presented in a
slender bottle of great
sophistication and beauty.

*La versione femminile di
Giorgio è presentata in fla-
cone slanciato in senso ver-
ticale di notevole classe e
bellezza.*

\mathcal{D}edicated to Rome, this 1988 perfume by Laura Biagiotti is shown here in the miniature version, which is a perfect replica of the original. Note the classical shape of the bottle by Lorente, who was inspired by a Roman column.

E' stato dedicato a Roma il profumo di Laura Biagiotti del 1988 che qui vediamo nella versione mignon, peraltro perfettamente identica all'originale. Notare la forma classicheggiante del flacone di Lorente, che si ispira alla colonna romana.

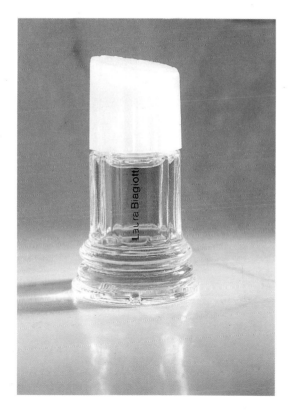

*T*his delightful miniature contains a thimbleful of Symbiose, a modern scent for women.

Questa deliziosa boccetta mignon contiene una piccola quantità di Symbiose, moderno profumo femminile.

*D*elirium, a fragrance that was introduced several years ago, has for some time been closely identified with the fashion house Liolà. The flask is classical and modern at the same time, with a black pastille-shaped top.

Ed ecco Delirium, una fragranza di pochi anni fa, da qualche tempo strettamente collegata alla casa di mode Liolà. Il flacone è classico e moderno insieme, caratterizzato dal tappo nero a forma di pastiglia.

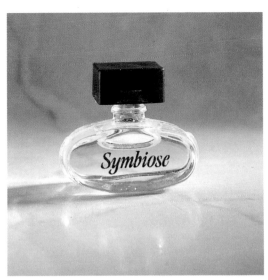

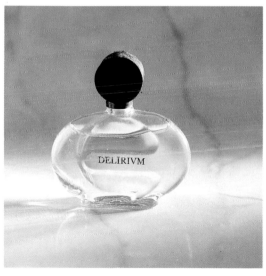

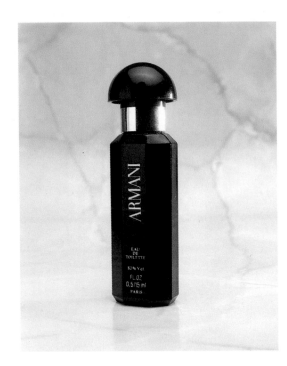

\mathcal{T}his handsome bottle, entirely in black, was personally chosen by Giorgio Armani in collaboration with the famous French designer Alain de Mourgues.

Tutto nero per Armani, l'elegante flacone scelto personalmente da Giorgio Armani in collaborazione col famoso designer francese Alain de Mourgues. ◄

\mathcal{E}legantly masculine is a good way to describe this miniature, identical to the full-sized bottle for the scent Polo. Note the attractive golden top and the image of the polo player highlighted against the green glass backdrop. The bottle was designed by Bernard Kotyuk.

Elegantemente maschile: ecco come si potrebbe definire la boccetta mignon, identica alla bottiglia grande, che contiene il profumo Polo. Notare il bel tappo dorato e l'immagine del giocatore di polo evidenziata sul verde del vetro. Il flacone è di Bernard Kotyuk. ➤

\mathcal{A} young and sporty air is to be expected from a bottle of fragrance by Lacoste, the company that produces the famous sportswear clothes with the little alligator logo.

Non poteva che avere un'aria giovane e sportiva il contenitore per il profumo Lacoste, legato alla casa produttrice dei famosi indumenti sportivi "firmati" col piccolo coccodrillo. ➤

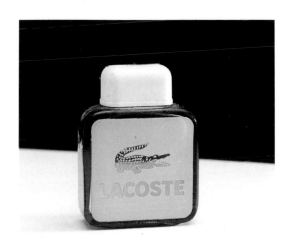

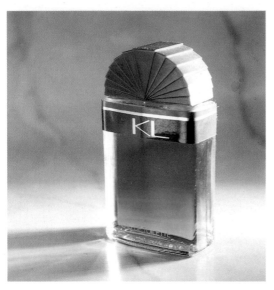

$\mathcal{K}.\mathcal{L}.$ are initials well known in the world of haute couture: they stand for Karl Lagerfeld, the brilliant and sophisticated creator of many lines of clothing for Chanel and others. This extremely elegant bottle was designed by Marc Rosen.

KL: due sigle ben note agli addetti al settore dell'alta moda. Sono le iniziali di Karl Lagerfeld, il geniale e raffinato creatore di tante linee di abiti, anche per la casa Chanel. Estremamente raffinato il flacone disegnato da Marc Rosen. ≺

\mathcal{A}n elegant contrast between bottle and top, for The Tenth, a scent by Napoleon; it loses nothing when reproduced in miniature.

Elegante il contrasto fra la bottiglia e il tappo, per il profumo The Tenth di Napoleon, che nulla perde anche nel formato piccolissimo. ➤

58

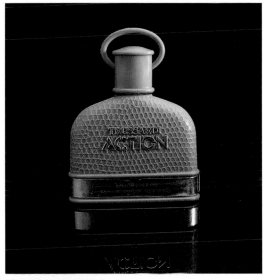

The couturier
Trussardi personally created
this container for his per-
fume Action. As can be seen,
this is one of the rare exam-
ples of a bottle that is not
made of glass.

*Il sarto Trussardi ha creato
personalmente il contenitore
per il suo profumo Action.
Come si vede, è uno dei rari
esempi di contenitori non di
vetro.* ➤

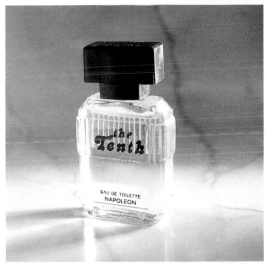

*T*his scent is the creation of another famous couturier, Regina Schrecker. The bottle, unique both in shape and material, is by Arnaldo Pomodoro, the famous Italian sculptor.

Questa è la creazione profumata di un'altra sarta famosa, Regina Schrecker. Il flacone, unico per forma e materiali, è di Arnaldo Pomodoro, l'illustre scultore italiano. ➤

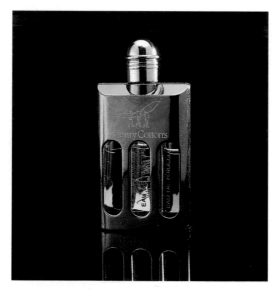

A very special presentation for three miniature bottles of scent from Henry Cotton's eponymously named fashion house. Though all three are for men, the fragrances are quite different aromatically.

Molto particolare la presentazione, in formato mignon, dei tre profumi Henry Cotton's, legati all'omonima casa di moda. Le fragranze sono tre, tutte destinate all'uomo, ma con diverso orientamento olfattivo. ◄

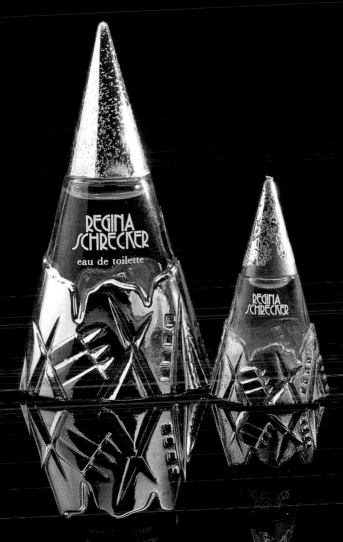

*J*aïs, one of the newest perfumes, in a distinctive bottle created by the designer Annegret Beier-Rosetti: an orb of green crystal with a superb windblown lotus flower on the top.

Jaïs, uno dei profumi più recenti, caratterizzati da un flacone creato dalla designer Annegret Beier-Rosetti: una boule verde cristallino, che ha per tappo una splendida corolla di fior di loto che pare mossa dal vento. ➤

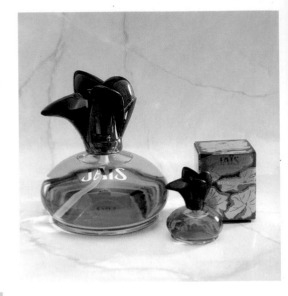

A perfume called Spuma di Sciampagna (Champagne Fizz) could only be presented in a champagne bottle, sealed with a slender golden cap.

Un profumo chiamato Spuma di Sciampagna non poteva che avere per contenitore una bottiglia da champagne, chiusa da un lungo tappo dorato. ◄

*T*he swan is the memorable feature of this elegant bottle containing Gloria Vanderbilt's perfume. The designer, Bernard Kotyuk, was inspired by a Lalique vase.

Il cigno è la nota caratterizzante del raffinato flacone che contiene il profumo Gloria Vanderbilt, designer. ➤

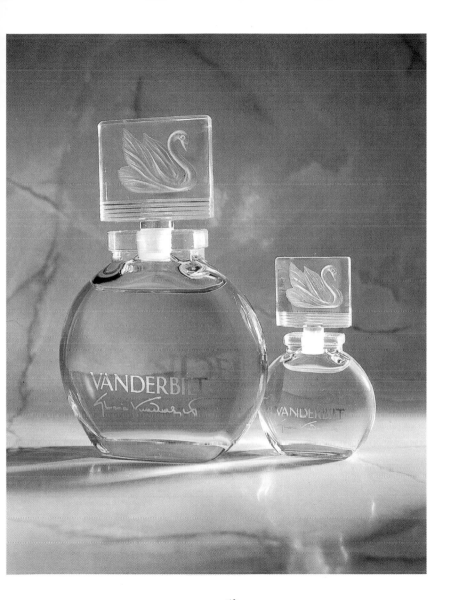

\mathcal{B}eautiful is the name of this fine perfume, intro-
duced by Estée Lauder in 1985. The bottle was
designed by I. Levy-Alain Carré.

*Si chiama Beautiful, è un profumo di classe prodotto
da Estée Lauder nel 1985. Il flacone, nel formato
normale, è stato realizzato da I. Levy-Alain Carré.*

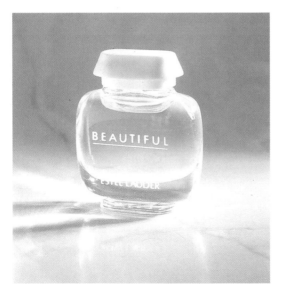

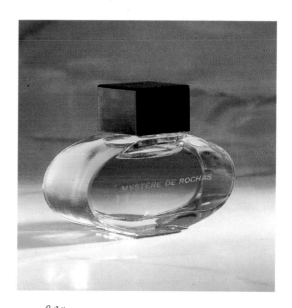

\mathcal{M}ystère is a floral-green perfume introduced by Rochas in 1978. Both simple and sophisticated, the bottle by R. Grani and S. Mansau is a minor masterpiece of harmony.

Mystère è un profumo fiorito-verde, messo in vendita nel 1978 dalla casa Rochas. Il flacone, semplice quanto raffinato, è opera di R. Grani e S. Mansau. Un piccolo capolavoro d'armonia.

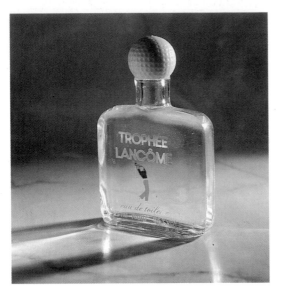

\mathcal{L}ancôme's Trophée, a sporty men's fragrance, was launched in 1982 and has enjoyed considerable success ever since. The bottle was designed by Pourtout.

Nel 1982 è stato lanciato Trophée di Lancôme, una fragranza per l'uomo sportivo che da allora riscuote molto successo. La bottiglia è stata disegnata da Pourtout.

≺

\mathcal{H}ere is Lancôme's latest perfume for women: Trésor, which appeared in 1990. The absolutely splendid bottle, by Areca, is in the shape of an inverted pyramid.

Questa è l'ultima fragranza femminile di Lancôme: si chiama Trésor, è del 1990. Assolutamente splendido il flacone di Areca, a forma di piramide rovesciata. ➤

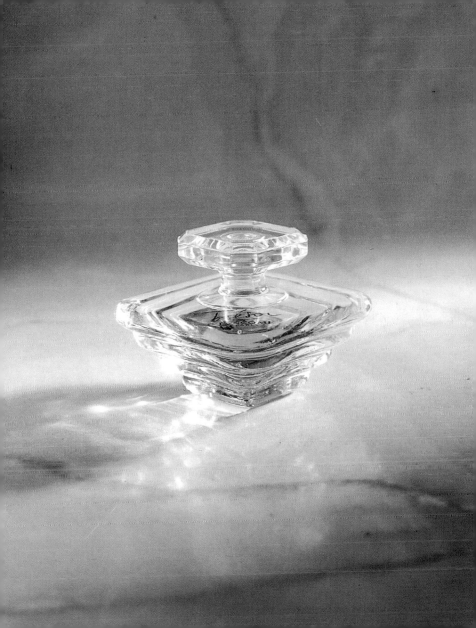

\mathcal{A}nother product from the house of Lancôme, Magie Noire, has remained highly successful since it first appeared in 1978. The beautiful bottle by Dinand is both classic and modern, in perfect harmony with the oriental-amber fragrance.

Siamo ancora in casa Lancôme con Magie Noire, altro grande successo che risale al 1978. Classico e insieme moderno il bel flacone di Dinand, in perfetta armonia con la fragranza orientale-ambrata.

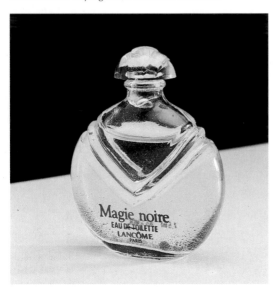

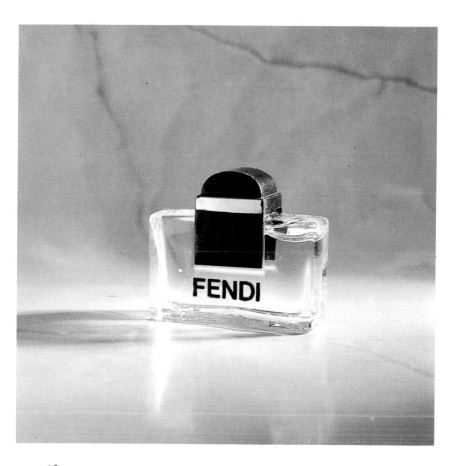

\mathcal{B}lack, crystal, gold, and amber adorn this bottle for Fendi, a perfume as youthful and up-to-date as the fashion house that launched it. A true work of art by Dinand.

Nero e cristallo, oro e ambra caratterizzano questo flacone del profumo Fendi giovane e moderno come la casa di mode che lo ha lanciato. Una vera opera d'arte di Dinand.

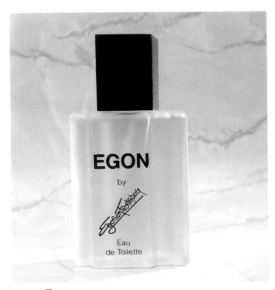

\mathcal{E}gon von Fürstenberg is one of the youngest leading designers of Italian men's fashion, and this is his fragrance: A tribute to the man of sophistication and elegance, who is capable of combining tradition and modernity. The bottle was designed by von Fürstenberg himself.

Egon von Fürstenberg è il nome di uno dei più gio-vani protagonisti della moda maschile italiana, e questo è il suo profumo: un omaggio all'uomo raffi-nato e di classe, capace di unire in sè tradizione e modernità. Il flacone è opera dello stesso Egon.

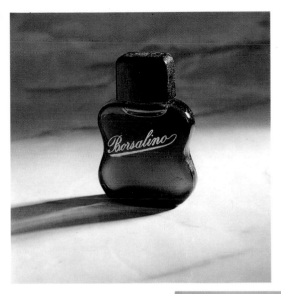

*B*orsalino is a name that embodies an entire era in the world of men's fashion. The bottle, even in this miniature version, is shaped like the famous Borsalino hat.

Borsalino: un nome che ha segnato un'epoca nel mondo dell'eleganza maschile. Il flacone, come si può vedere anche nella versione mignon, ha la forma che ricorda la famosa piega del cappello.
◄

*H*ere is Caractère, by Daniel Hechter, a fashion designer who has articulated his own very contemporary style. The spicy woody fragrance is presented in a classic bottle by Dinand.

Ed ecco Caractère di Daniel Hechter, creatore di moda che ha inventato uno stile adatto alla nostra epoca. Il profumo, è uno speziatolegnoso racchiuso nel classico flacone di Dinand. ➤

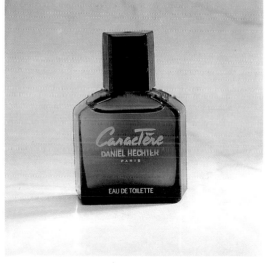

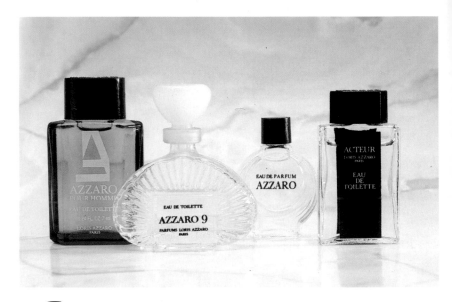

\mathcal{F}our different interpretations of the perfume bottle: The fragrances, for men and women, are by Loris Azzaro; the bottles, here in the miniature versions, are by Atelier Dinand.

Quattro modi diversi di interpretare il flacone per profumo. Le fragranze maschili e femminili sono prodotte da Loris Azzaro; le bottiglie, qui in versione mignon, sono di Atelier Dinand.

\mathcal{A} perfume named simply Ungaro: six letters colored with magic. The miniature stands alongside the full-sized bottle, a true work of art designed by Jacques Helleu for Emanuel Ungaro, the great French couturier of Italian extraction.

Si chiama semplicemente Ungaro, sei lettere colorate di sortilegi. Alla boccetta mignon è accostato il flacone di misura normale, una vera opera d'arte disegnata da Jacques Helleu per Emanuel Ungaro, grande sarto francese di origine italiana. ➤

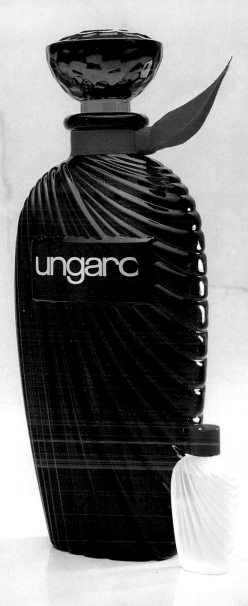

\mathcal{T}he sophistication of Voile, a fragrance by Anna Marchetti with a strong bittersweet note, is emphasized by a memorable bottle of exquisitely faceted crystal.

La classe di Voile, la fragranza di Anna Marchetti, dall'importante bouquet dolce-amaro, è sottolineata dalla ricercata confezione in prezioso cristallo sfaccettato.

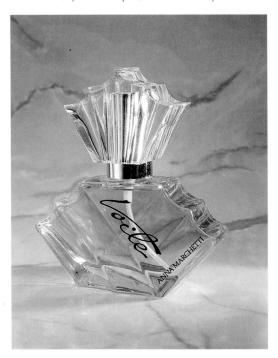

When luxury is transformed into art: this phrase has been used to describe Christian Lacroix, the brilliant Parisian fashion designer and avant-garde artist of indisputable fame. His perfume, C'est la Vie!, comes in an exquisite bottle with a coral top. Next to the miniature bottle is the splendid purse spray, whose sinuous lines were inspired by a branch of coral. The designer was Maurice Roger.

Quando il lusso si trans forma in arte: così qualcuno identifica Christian Lacroix, il geniale stilista di moda parigino, artista d'avanguardia di indiscussa fama. Il suo profumo e C'est la Vie! presentato in un prezioso flacone che si conclude con un tappo di corallo. Accanto alla buccetta mignon, lo splendido vaporizzatore da borsetta di forma sinuosa, ispirata allo stilista da un ramo di corallo. Design: Maurice Roger.

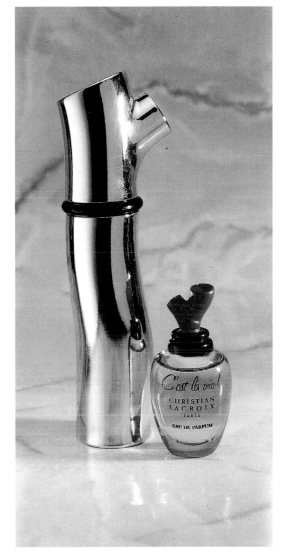

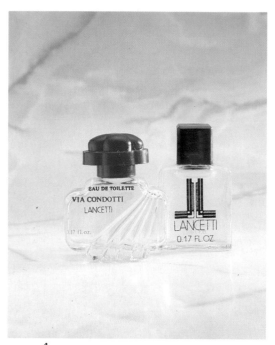

\mathcal{A}t left, a miniature bottle for Lancetti's Via Condotti, designed by Atelier Dinand; at right, Lancetti Uomo: two different interpretations of the elegance and sophistication that is associated with a master of high fashion.

A sinistra, mini flacone per Via Condotti di Lancetti, opera di Atelier Dinand; a destra, Lancetti Uomo: due modi diversi di interpretare la classe e l'eleganza legate al nome di un maestro di moda.

*T*his exquisite crystal bottle with an equally exquisite top was created for Christie, a floral-green perfume by Veejaga. The miniature perfectly echoes the beauty of the larger bottle.

Per Christie, un profumo fiorito-verde prodotto da Veejaga, è stato studiato questo prezioso contenitore in cristallo chiuso da un tappo altrettanto prezioso. La boccetta mignon riesce perfettamente a rendere la bellezza della bottiglia più grande.

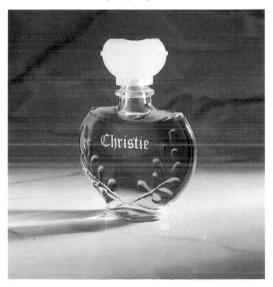

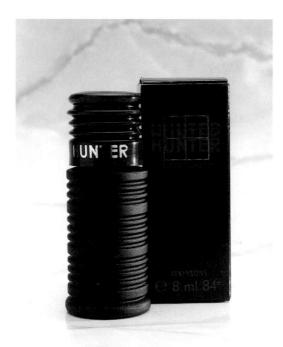

*H*unter, a highly successful men's fragrance, was produced by Atkinsons in 1987. Note the elegance of the all-black bottle, with the name emblazoned on the edge of the cap.

Si chiama Hunter questo profumo maschile di grande successo prodotto da Atkinsons dal 1987. Notare l'eleganza del flacone completamente nero con la scritta in evidenza subito sotto il coperchio.

\mathcal{W}ith Panthère, launched in 1987, we enter the refined world of French jeweler Cartier. The panther that gives its name to the fragrance is clearly visible even on the miniature bottle created by Pochet and du Courval.

Entriamo nel raffinato mondo del gioielliere francese Cartier con il suo Panthère lanciato nel 1987. La pantera che ha dato il nome alla fragranza è ben visibile anche nella boccetta mignon. E' una creazione di Pochet et du Courval.

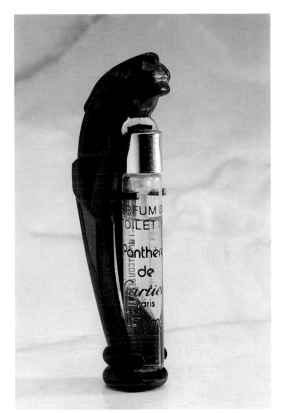

\mathcal{T}his miniature bottle, seen here in two sizes, was designed in perfect harmony with the fragrance Tuscany, by Aramis, launched in 1985.

Per Tuscany di Aramis, profumo lanciato nel 1985, è stato ideato il mini-flacone che vediamo in due misure, che armonizza perfettamente con la fragranza.

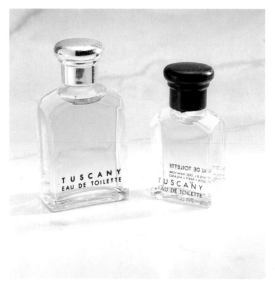

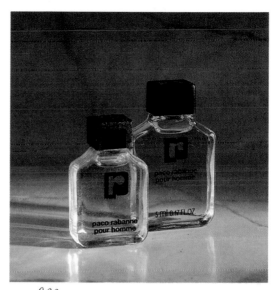

*M*any scents for both men and women have been launched by the famous designer Paco Rabanne. All are unmistakable for the quality of the fragrances and the beauty of the bottles, which were designed by masters of the art.

Sono numerosi i profumi lanciati dal famoso stilista Paco Rabanne sia per donna, sia per uomo. Inconfondibili per la classe della fragranza e la bellezza dei flaconi disegnati da maestri del settore.

\mathcal{F}our charming miniatures, containing as many scents from the house of Rancé and distinguished by the colors of their bows and their individual labels.

Deliziose le quattro bottigliette mignon che contengono altrettanti profumi della casa Rancé, caratterizzati dal diverso colore dei fiocchi e delle etichette. ➤

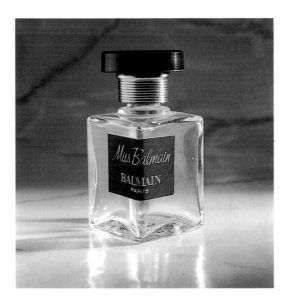

\mathcal{M}iss Balmain, a delicate fragrance from the famous Parisian fashion house, ushers us into a feminine world of the highest sophistication.

Entriamo in un mondo femminile di altissima raffinatezza con Miss Balmain, delicata fragranza della celebre casa di mode parigina.
◄

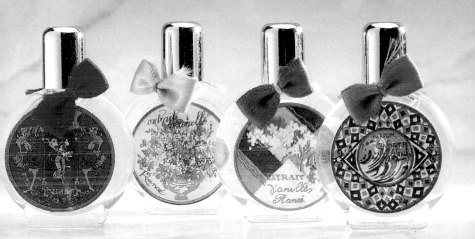

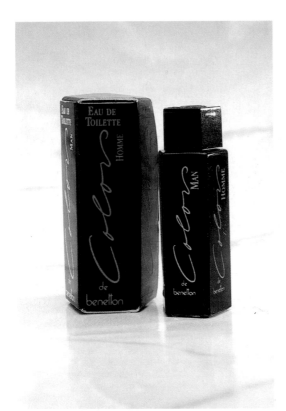

*M*odern, attractive, and original, the bottle for Benetton's Colors for men is black and hexagonally shaped, like its box, with vivid lettering that evokes the colorful world of Benetton.

Moderno, simpatico, originale il contenitore per Colors per uomo di Benetton di forma esagonale come l'astuccio egualmente nero con le scritte a vivaci colori che richiamano alla mente il coloratissimo mondo di Benetton.

\mathcal{A}n extremely delicate fragrance created by D & D for young women in the flower of youth: Segreti di Debby, a non-alcohol-based floral scent, introduced in 1987. The bottle, as fresh as its contents, is by Dinand.

Ecco una fragranza delicatissima creata da D & D per le ragazze in fiore; è Segreti di Debby, un ciprato fiorito del 1987. Il flacone, fresco come il contenuto, è di Dinand.

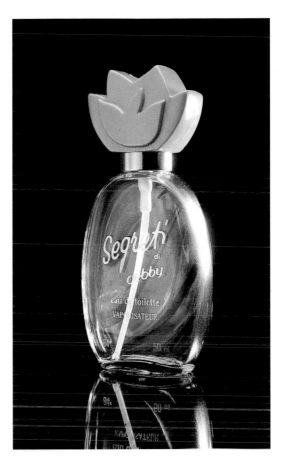

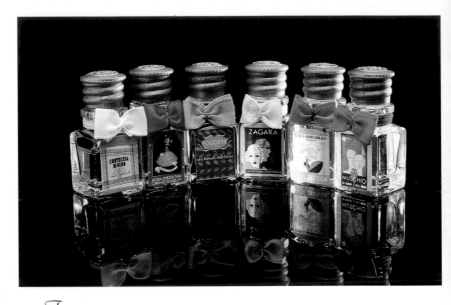

\mathcal{F}or collectors of miniature perfume bottles, the illustrious house of Borsari of Parma has for several years produced little bottles like these, which contain some of the company's most famous fragrances.

Per i collezionisti di mini-profumi la gloriosa casa Borsari di Parma da qualche anno mette in vendita boccettine come queste che contengono alcune fra le più note fragranze di sua produzione.

\mathcal{E}ntirely in a delicate shade of pink, this delightful creation is for Lovetime by Visconti di Modrone.

Tutta giocata su un tenerissimo rosa è la deliziosa con-fezione di Lovetime di Visconti di Modrone. ➤

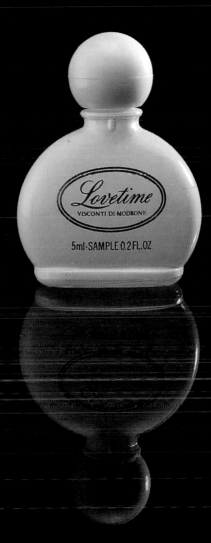

*C*uoio by Borsari 1870 is a spicy-woody scent that was launched in 1989. The classic bottle with square lines is similar to others from this house.

Cuoio di Borsari 1870 è uno speziato-legnoso lanciato nel 1989. Classico il flacone di linea quadrata, simile ad altri della casa.

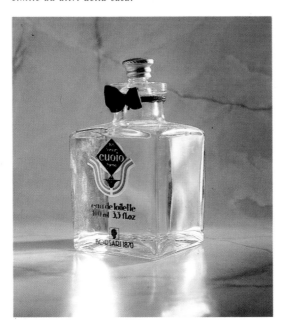

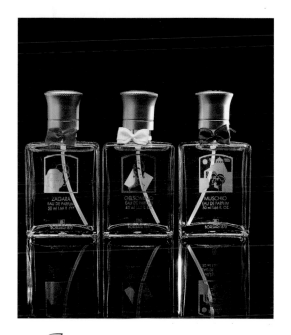

\mathcal{T}hree more scents by Borsari. For many years, these bottles were custom-made by the Bormioli company of Parma.

Nella foto sono riuniti altri tre profumi sempre di Borsari. I flaconi sono stati per molti anni creati appositamente dalla società Bormioli di Parma.

\mathcal{W}e return to the world of high fashion with this miniature bottle of the scent that has been one of the crowning achievements of Gianfranco Ferrè.

Torniamo nel mondo dell'alta moda con la boccetta mignon del profumo che ha suggellato il successo del sarto Gianfranco Ferrè.

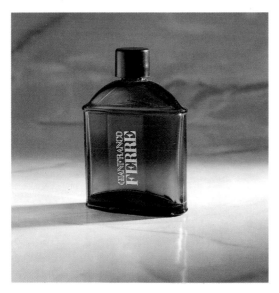

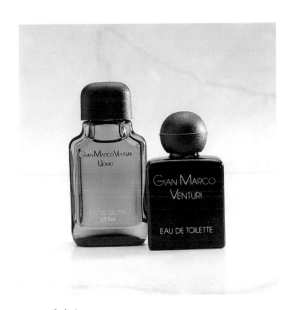

\mathcal{W}e remain in the world of Italian style with GianMarco Venturi's fragrance, which comes in both men's and women's versions.

Restiamo fra gli stilisti dell'alta moda italiana col profumo di GianMarco Venturi. Esiste nella versione maschile e femminile.

\mathcal{D}avidoff, a fragrance for men, is presented in this miniature bottle that is most handsome in its simplicity; the black top lends it a modern accent.

Si chiama Davidoff ed è un profumo maschile il contenuto di questa boccetta mignon molto bella nella sua semplicità, modernizzata dal tappo nero.

\mathcal{M}arbert Gentleman, a semi-oriental scent, was the second fragrance produced by this house. The miniature reproduces in every detail the elegance of the original design, including the horizontal fluting on the upper section.

Marbert Gentleman: un semi-orientale aromatico, seconda fragranza della casa. La boccetta mignon riporta fin nei particolari la classe del flacone scanalato orizzontalmente nella parte superiore.

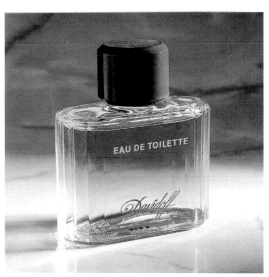

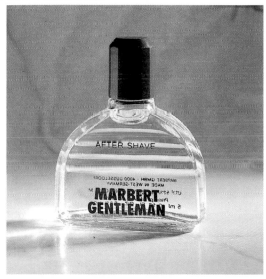

\mathcal{N}ino Cerruti, the Italian master of elegance, has created two scents; shown here is his men's fragrance, accompanied by its box. The bottle was designed by Dinand.

Nino Cerruti, maestro italiano di eleganza, ha creato due profumi: qui vediamo la versione maschile accanto all'astuccio. Il flacone è di Dinand.

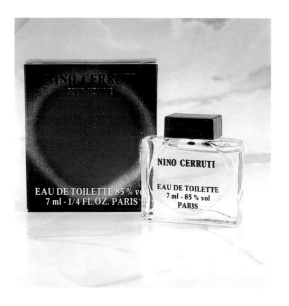

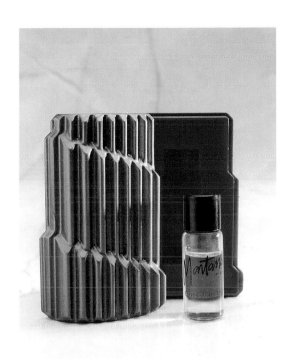

\mathcal{I}n the unusual presentation of the miniature
version of Montana's men's fragrance, more emphasis
is placed on the box than on the bottle.

*Curiosa la presentazione di Parfum d'Homme di
Montana che nella versione mignon dà più impor-
tanza all'astuccio che al flacone.*

*B*yzance, by Rochas, was released in 1987 and enjoyed great success, because of its floral-aldehyde fragrance and its bottle (shown here in two sizes) designed by In House.

Byzance di Rochas è stato presentato nel 1987 e ha avuto grande successo sia per la fragranza fiorita-aldeidata, sia per il flacone di In House che vediamo in due misure. ➤

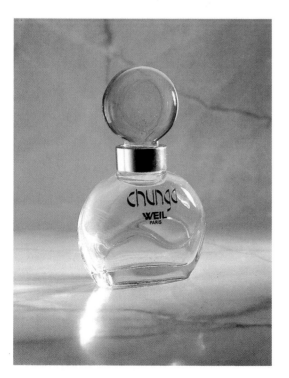

*C*hunga, by Weil, is a feminine scent, as suggested by its dainty bottle with a translucent pastille-shaped top encircled by a metal ring.

Con Chunga di Weil torniamo fra i femminili come si può intuire osservando il flaconcino col tappo trasparente a pastiglia chiuso alla base da un anello metallico. ◄

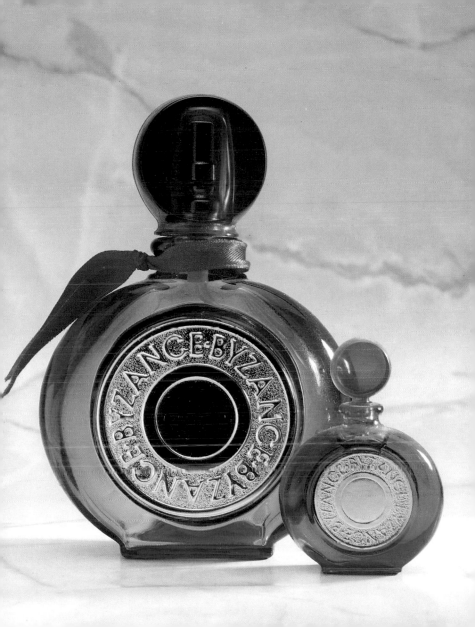

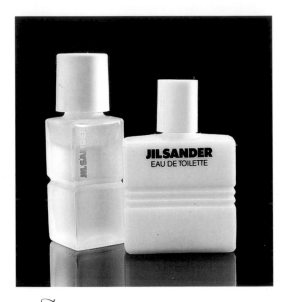

\mathcal{D}ecisive rectangular lines characterize these bottles of men's and women's scents from Jil Sander.

Di linea decisamente squadrata i flaconi per i due profumi, maschile e femminile, di Jil Sander.

\mathcal{E}ntirely in clear glass, without the black lacquer of the large bottle, this miniature bottle of Gianfranco Ferrè projects great style.

E' tutta in vetro trasparente, senza la lacca nera che caratterizza la bottiglia grande, questa boccetta mignon del profumo Gianfranco Ferrè, comunque di gran classe.

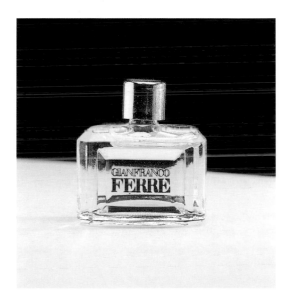

\mathcal{L}'Incomparable, by Napoleon, has a decidedly modern, vertical design, dominated by an imposing black top.

La mignon di L'Incomparable di Napoleon ha una linea decisamente moderna e verticale, dominata dall'importante tappo nero.

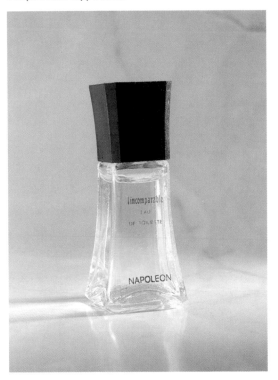

Oscar de la Renta is one of the most successful American designers. Shown here are the miniature bottles for his two fragrances, the one for women on the right, and the men's on the left.

Oscar de la Renta è uno degli stilisti americani di maggior successo. Ecco le boccette mignon dei suoi due profumi: femminile, a destra, e maschile, a sinistra.

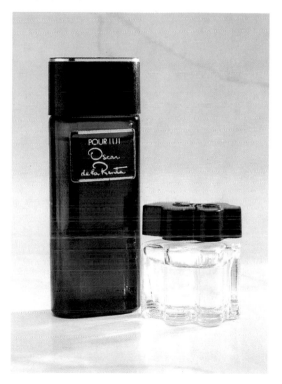

\mathcal{F}or Vent Vert, by Balmain, a great success in 1947 that was relaunched in 1990, an exquisite presentation was chosen: a miniature hatbox holds a bottle topped with a windblown leaf.

Per Vent Vert di Balmain, grande successo del 1947 rilanciato nel 1990, si è scelta questa preziosa presentazione: l'astuccio è una minicappelliera e il flacone è sovrastato dal tappo a forma di foglia che pare mossa dal vento. ➤

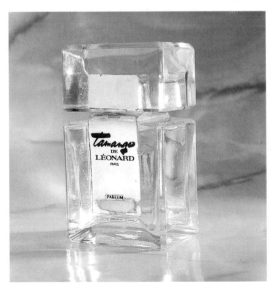

\mathcal{A} splendidly compact bottle for Tamango, by Léonard, achieves its dramatic effect entirely through the transparency of glass. It was designed by Serge Mansau.

Splendida nella sua compattezza la bottiglia del profumo Tamango di Léonard, tutta giocata sulla trasparenza del vetro; è di Serge Mansau.
◄

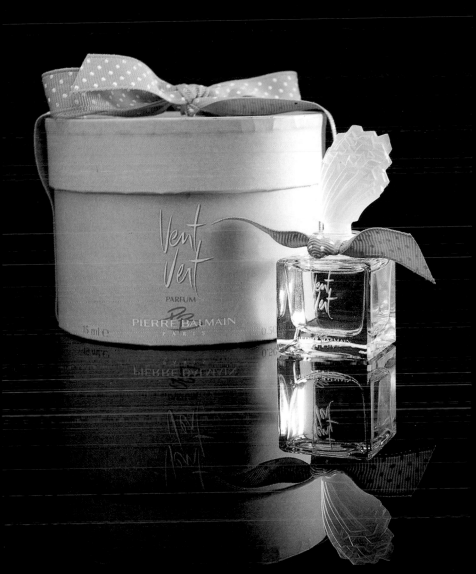

\mathscr{B}asile, Soprani, Versace: three of the most famous names in international high fashion. Here are the miniature bottles for three of their fragrances. The first is made of glass and lacquered plastic, the second is from Atelier Dinand, and the third, cubic in shape, was designed by Pierre Dinand himself.

Basile, Soprani, Versace: tre fra i nomi più famosi dell'alta moda internazionale. Queste sono le boccette mignon di tre loro profumi. La prima è in vetro e plastica laccata, la seconda è di Atelier Dinand, la terza, che ha la forma perfetta del cubo, è stata disegnata proprio da Pierre Dinand.

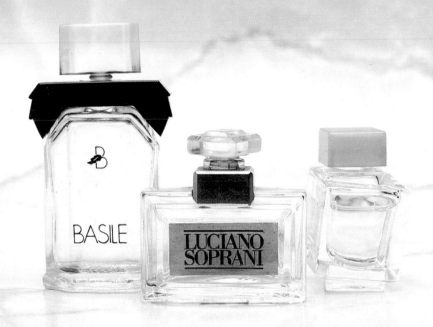

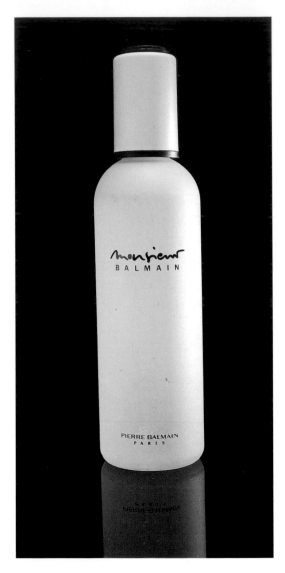

\mathcal{Y}ellow satin-finished glass with a soft rubber top: here is the bottle created for the relaunch of a classic men's fragrance. Monsieur Balmain was introduced in 1949 and revived in 1969; now it has been reintroduced in this new design.

Tutto rigorosamente giallo in vetro satinato, col tappo in morbida gomma: è l'ultimo flacone ideato per il rilancio di un classico maschile. Si tratta di Monsieur Balmain realizzato nel 1949, rivisitato nel 1969 e ora riproposto nella nuova veste.

◄

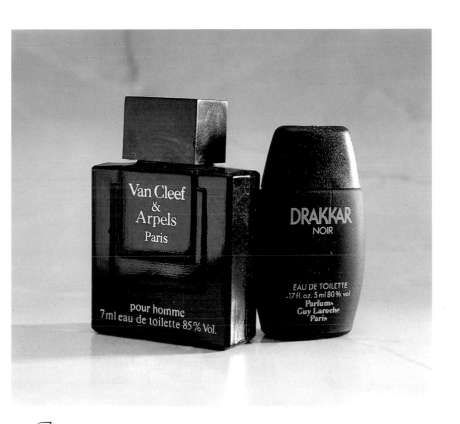

Two more men's fragrances in rigorously black miniature bottles. On the left, Van Cleef & Arpels for men; on the right, Drakkar Noir, by Guy Laroche, in a flask designed by Laroche himself.

Restiamo fra i maschili con queste due boccette mignon rigorosamente nere: a sinistra è quella del profumo Van Cleef & Arpels da uomo; a destra Drakkar Noir di Guy Laroche. Questo flacone è opera dello stesso Laroche.

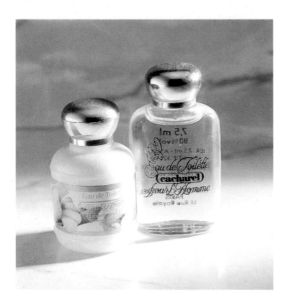

Cacharel's fragrance Anaïs Anaïs comes in the lovely miniature bottle on the left, in opaline glass with a flower motif, designed by Annegret Beier-Rosetti in 1978. On the right, Cacharel for men, 1981.

Si chiama Anaïs Anaïs il profumo di Cacharel contenuto nella bellissima mignon a sinistra, in opaline con motivi floreali, disegnata nel 1978 da Annegret Beier-Rosetti. Sulla destra, Cacharel pour Homme del 1981. ◄

This highly original and elegant presentation for the miniature bottle of Paloma Picasso, accompanied by a perfumed cream, was personally designed by Pablo Picasso's daughter in 1985.

Presentazione originalissima e di rara eleganza per la boccetta mignon di Paloma Picasso, accompagnata dalla crema profumata. E' stata disegnata personalmente dalla figlia di Pablo Picasso nel 1985. ➤

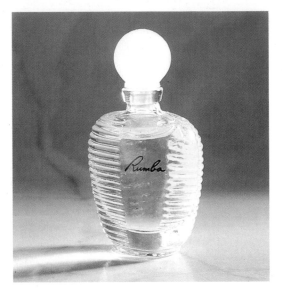

*R*umba, by Balenciaga, is the perfume contained in this sophisticated miniature bottle of horizontally fluted glass with an opaline stopper. It was introduced in 1988.

Rumba è il profumo di Balenciaga contenuto in questa raffinata mignon in vetro scanalato orizzontalmente, col tappo di opaline. E' del 1988.

◄

*T*he original bottle for Arrogance for women was designed in pink plastic. Beside it is a miniature bottle in glass. The large version is by Atelier Dinand.

E' stato ideato per Arrogance pour Femme l'originale flacone in materiale plastico rosa. A lato, boccetta mignon in vetro. La versione grande è di Atelier Dinand. ➤

ARROGANCE

POUR FEMME

 100 ml ℮ 3.33 FL.OZ

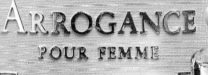

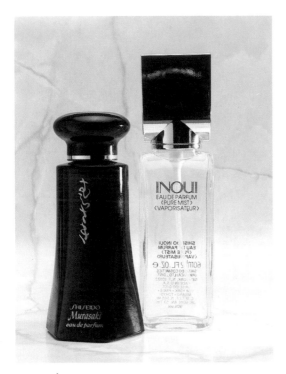

\mathcal{A} leap to the other side of the world—to
Japan, where Shiseido created Murasaki (on the left)
in 1980, and Inoui, shown in the spray version, in
1977.

Un balzo all'altra parte del mondo e siamo in
Giappone dove Shiseido ha creato nel 1980 Murasaki
(a sinistra nella foto) e nel 1977 Inoui, che vediamo
nella versione spray.

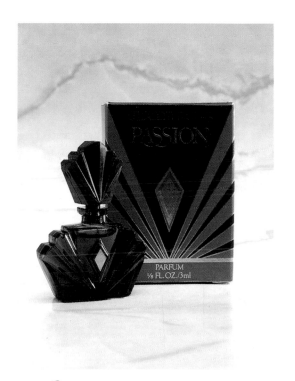

\mathcal{E}lizabeth Taylor's Passion is a semi-oriental floral fragrance launched in 1988. The exquisite bottle is an intense shade of violet, like the eyes of the famous actress, and the box is the same color.

Passion di Elizabeth Taylor è un semi-orientale fiorito lanciato nel 1988. Il prezioso flacone è di un viola intenso, come gli occhi della famosa attrice; anche l'astuccio è dello stesso colore.

These bottles in the form of lips, closed with opaque glass "noses," were designed by Salvador Dalí and contain his well-known, eponymously named women's perfume. On the right, a soap from the same line.

I flaconcini a forma di labbra, chiusi da "nasi" in vetro opaco, firmati Salvador Dalí, propongono la nota fragranza femminile omonima; sulla destra, un saponcino della stessa serie.

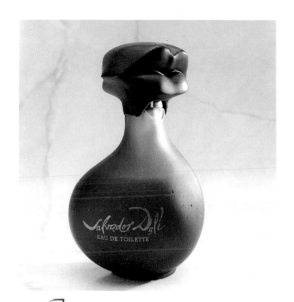

\mathcal{T}his bottle of rare beauty and originality was designed by Salvador Dalí for the men's fragrance that bears his name.

Flacone di rara bellezza ed originalità questo ideato da Salvador Dalí per la fragranza maschile che porta il suo nome.

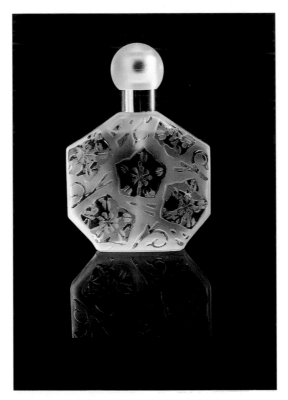

This perfume, Ombre Rose, is made in France for Jean Charles Brosseau. The bottle, shown here in the translucent version for the eau de toilette, is an exquisite work of art, ornamented with a floral pattern cut in relief on the frosted glass.

Il profumo si chiama Ombre Rose ed è prodotto in Francia per Jean Charles Brosseau. Il flacone, qui nella versione trasparente per la eau de toilette, è una squisita opera d'arte, ornato com'è da un motivo floreale smerigliato in rilievo.

*W*e remain in France with Cacheral's
Loulou, a semi oriental floral fragrance in a
splendid and highly original bottle designed by
Annegret Beier-Rosetti.

*Torniamo in Francia con Loulou di Cacharel, un
semi-orientale fiorito che ha trovato in Annegret
Beier-Rosetti il design che ha creato il suo origi-
nalissimo e splendido flacone.*

\mathcal{E}legant, classic, and modern, the fragrance Prada has carried the name of Milan's historic maker of leather goods throughout the world of perfumes in this unique, sophisticated bottle designed by Joël Desgrippes.

Elegante, classico, moderno, il profumo Prada che deve portare in giro per il mondo della profumeria il nome della storica casa di pelletterie di Milano, è racchiuso in questo flacone diverso da ogni altro e di gran classe, firmato da Joël Desgrippes. ➢

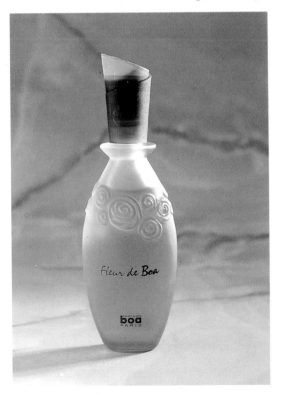

\mathcal{A} unique style of bottle was created by Serge Mansau for Fleur de Boa, a non-alcohol-based floral scent introduced in 1988, inspired by the youthful fashions of Boa, the noted Parisian fashion house.

Completamente diverso lo stile del flacone ideato da Serge Mansau per Fleur de Boa, un ciprato fiorito del 1988, ispirato alla moda giovane di Boa, la nota casa parigina.
⤙

The Collezione Floreale by Borsari: six miniature glass bottles with Art Nouveau–style tops, presented in a silver box. The essences are wisteria, lily of the valley, tea rose, tuberose, Parma violet, and peony.

Ecco la Collezione Floreale di Borsari: sei boccette mignon in vetro dal tappo in stile Liberty, riunite in un cofanetto argentato. Le essenze sono al glicine, mughetto, rosa tea, tuberosa, violetta di Parma, e peonia.

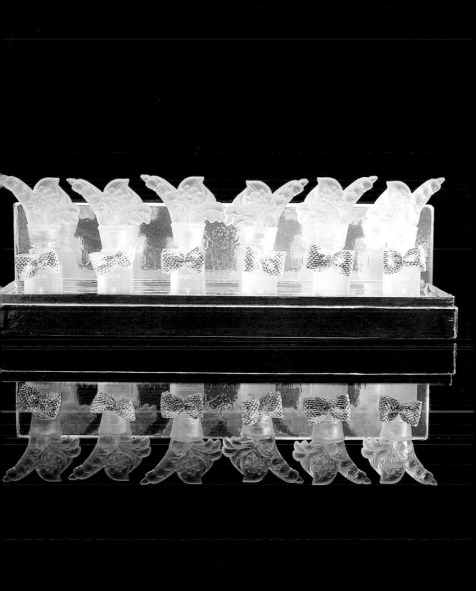

\mathcal{M}olto, by Missoni, is a "warm" perfume intended to arouse strong emotions. The striking, ultramodern flask is as colorful as Missoni's fashions.

Molto di Missoni è un profumo "caldo", che sa suscitare forti emozioni. Coloratissimo, come la moda Missoni, il suo bel flacone ultra-moderno.

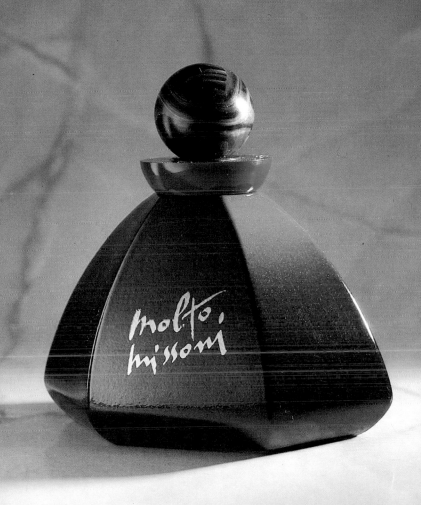

Perfume Bottles

\mathcal{T}he oldest perfume bottles date back four or even five thousand years. Made of alabaster, terra-cotta, or glass paste, their colors may be delicate—or vivid: yellow and turquoise, red and emerald green, blue and orange. And they come in many different shapes, depending on when and where they were made; some are like little amphoras, others are like curled cups, while others look like miniature flower vases.

The first perfume bottles in history came from the Middle East, Egypt, the lands of the Sumerians and Phoenicians, Babylonia, Carthage, Tarquinia, Athens, and of course from the territories of the Roman Empire. They did not contain liquids, but rather oils or pastes, whose composition is still something of a mystery, but which were so well formulated that even today, thousands of years later, they have often astonished archaeologists with their intense fragrance.

Before we examine the modern perfume bottles that are the focus of this book, let's take a step back in time to the lands where the first perfumes were most likely created: the Middle East, Arabia, and the Egypt of the pharaohs.

PERFUME OF THE PHAROAHS

\mathcal{H}istorians and archaeologists cannot tell us who deserves the credit for the discovery of perfumes, but one thing is undeniable: From the time perfumes were first used, people valued them to an extraordinary degree, even dedicating them as offerings to the gods.

Excavations have shown that in Egypt, for example, two or three thousand years before Christ, every major temple had a garden nearby where flowers and aromatic herbs were cultivated, and a workshop where the products from the garden were processed. Here, the priests mixed fragrant herbs and petals with precious, rare resins imported from distant regions. The formulas, complicated and highly secret, were written on the laboratory walls, so as not to be lost. The risk of their being stolen was fairly low, since in those days few could read and write, aside from the priests and the ruling class. The Egyptians believed that the god Thoth himself had dictated the formulas, in times so ancient as to have been almost forgotten. And for that reason it was strictly forbidden, on pain of death, to take the secret from the temple and make perfumes for private use.

Aromatic incense was also burned on the altars of Babylon and Nineveh, and all sacred spaces were perfumed with fragrant essences. People believed their prayers reach the gods more rapidly if they were borne on clouds of incense. In short, they associated perfume with immortality. This idea arose partly because the raw materials needed to produce a perfume were so very difficult to obtain, and so very expensive, that only kings and high priests could afford them. The gum called frankincense, for example, as well as myrrh and balsam, came from India, Arabia or Africa; and the merchants who had to undertake long and arduous voyages to acquire them surrendered their wares only in exchange for gold and precious stones.

But the day came in Egypt when the pharaoh and other rich and powerful men decided to rebel against the commands of the high priests, and began using perfumes for personal pleasure. Because it was necessary to bathe several times a day to refresh oneself in that burning climate, the upper classes took great pleasure in adding a few drops of perfumed, aromatic essence to the bath water. In addition, the most sophisticated developed the habit of being massaged with aromatic oils or ointments that not only gratified the sense of smell, but often invigorated the body. By the time of the Ptolemies, actual perfume factories—the most important in the world—had sprung up all over Egypt. Hundreds of skilled laborers worked in them, and as they left the factories at the end of each day, they were carefully searched to make sure they were not carrying off samples or secret formulas.

The more widespread the use of perfumes became, the more numerous and varied were the objects in which they were contained and stored in the private chambers of kings, princes, and governors, or in the halls where subjects were received or guests assembled for banquets. Women had already begun investigating ways of carrying their preferred perfumes with them at all times. In Egypt a particularly strange fashion arose, which was adopted even by the legendary Cleopatra herself: women of the court arranged a cone of fat impregnated with a favorite perfume on their head, between the hair and commonly worn wig. As the heat of the body melted the cone, the wearer would be cloaked in fragrance. This rather questionable practice did not spread far beyond Egypt, although wigs were perfumed in more subtle ways for centuries.

But what were the fabulous "perfumes of Araby?" Balsam, cinnamon, calamus and cassia, sandalwood, aloe, patchouli, and frangipani were so called (though they came in fact from lands much farther away, such as Ceylon or India) because the merchants who spread them throughout the world shipped them from Arabia.

THE CONQUEST OF THE MEDITERRANEAN

 ${\mathcal{E}}$ gyptian perfumes first traveled to Greece, where they became a branch of medical science, then moved on to Rome where their use became widespread among the upper classes. Even generals adored them to the point of having army standards and insignias

bathed with fragrant essences before a battle. In the capital of the Empire, an entire street was set aside for the makers and sellers of perfumes, and it was one of the busiest in town, much frequented by both men and women. Among the preferred scents were *rhodium*, from roses; *melinum*, from quinces; *narcissinum*, from narcissus; *cyprium*, from henna flowers mixed with others; and the so-called "royal unguent," made of twenty-seven fragrances. There were also personal perfumes, custom-mixed for a beautiful woman, powerful sovereign, or sophisticated man. Hosts had their guests strewn with fragrant flower petals at important banquets; people rubbed their bodies with precious oils at home or at the baths, after bathing or taking exercise; and perfumes anointed the most famous athletes and victorious warriors.

It was in imperial Rome that little perfume containers first made their appearance—forerunners of the dainty bottles that have delighted elegant modern men and women for decades, and which today are objects of desire for passionate collectors. These perfume containers, which eventually became known as "pomanders," were little round receptacles of wood, gold, or silver, often encrusted with precious stones, and decoratively perforated. The user placed a dab of perfumed ointment inside, and its exquisite scent escaped through the many little holes. Those who used them—and there were a great many in ancient Rome—wore these pomanders (as we will call them for the sake of simplicity) hanging from a necklace or fastened to

their belts, in order to constantly surround themselves with a cloud of fragrance.

The Romans' boundless enthusiasm for fragrances of all kinds, to be used on scores of occasions, was bequeathed to the Byzantines, who indulged themselves even more. In the splendid city now called Istanbul, during the time of the Eastern Roman Empire, the public squares flowed with fountains of perfumes, while fragrant resins smoldered everywhere in exquisite incense burners. Perfumed essences were burned in Christian churches, just as they had been in pagan temples. An entire gallery of the Great Bazaar was dedicated solely to the perfume market. Perfumes were often presented to the buyer in precious glass or golden flasks, which men and women carried with them everywhere, both at home and away. These early pomanders, made of ivory, glass, or ceramic, and very small in size— sometimes no more than three-quarters of an inch long—were often set in jewelry; some women preferred to wear them dangling from their sandals, so that with every step they filled the air with a heady fragrance.

PERFUME IN THE ISLAMIC WORLD

This fashion was passed on to the Middle East, where it quickly became very widespread. During the seventh and eighth centuries, now-Islamic Egypt once again became the great homeland of

perfumery, in a vigorous revival of the ancient tradition. Here famous perfumers studied distillation, writing important treatises on the subject. It was probably during this era that the first distillates appeared, particularly rose water, one of the true glories of the East.

Also around this time, two scents that would play a fundamental role in the evolution of perfumery were added to the list of the classic "perfumes of Araby": musk and ambergris, which were even more costly than frankincense and myrrh because they were rarer and far more intense. These two substances are very odd indeed. Musk is the secretion from scent glands peculiar to the male of an Asian ruminant called the musk deer; ambergris is an oily, fragrant secretion of the sperm whale that solidifies on contact with air. It was not entirely untrue, then, when the famous caliph Harun al-Rashid stated with great authority that "this substance [Ambergris] emerges from springs at the bottom of the sea, like the naphtha at Hit."

The prophet Mohammed himself was never ashamed of saying that in his life he had loved three things above all others: women, children, and perfumes. It is no surprise, then, that in the Koran—the religious and civil code governing the organization of Islamic society—perfumes enjoy a position of great importance both during earthly existence and in the afterlife. The following fact should be enough to show how highly the followers of the Prophet esteemed fragrant substances: When some of the most important mosques in Islam were being built, to ensure that these sacred places were filled with sweet smells, the mortar itself was mixed with rare and costly

musk, creating an atmosphere so fragrant as to be almost suffocating during the warmest hours of the day.

Islamic men in general used little perfume on their bodies, but applied it liberally to gloves, divans, carpets, and tapestries. And they were very fond of foods—particularly sweets and sorbets—flavored with aromatic essences. Guests were showered with fragrant flower petals on arrival, and sweet scents surrounded them constantly while they talked, relaxed, and ate. Immense braziers were put into service in every room, hour after hour, partly for pleasure, and partly to purify the atmosphere and to ward off evil spirits.

Islamic women perfumed themselves with abandon, and invented a tiny perfume holder that was as practical as it was unusual. This was a rosary of prayer beads, of the type used by every good Muslim, interspersed with little perforated beads of wood or glass. Inside each of these pearls was a substance imbued with the woman's favorite fragrance, so that she was constantly surrounded by a unique fragrance that added to her allure.

After the decline of the Islamic world, Venice adopted this curious custom, and began producing millions of these portable perfume "pearls" in the glass factories on the island of Murano. In the thirteenth century, Venice became the main European center for the production of colored-glass beads and perfume containers. Often the larger containers were true works of art, made by the "*millefiori*" technique, or fashioned to resemble precious gems. From Venice this fashion quickly spread all over Europe, where it was widely imitated.

In the meantime, the Spanish, whose country had been dominated and occupied by the Arabs for centuries, became masters of the complex and somewhat magical art of perfumery. Little by little, perfumes became part of people's everyday lives. They were increasingly used to enhance the bath, to make homes more elegant, to enliven festivities, and to add solemnity to religious ceremonies. On feast days, fountains in the plazas were filled with aromatic liquids for the enjoyment of the common people. From Spain, the love of perfume spread throughout Europe. It is believed that Hildegard of Bingen, a German nun, herbalist, physician, and expert in distillation, invented lavender water, which has remained a great favorite over the centuries.

Naturally, as perfumes grew increasingly popular, it became necessary to invent new containers for them, in order to preserve their fragrance and keep them safe when they were carried for long distances. These portable perfume containers were made of ceramic, glass, bone, ivory, crystal, or precious metals. They were almost always very compact, much smaller than modern perfume bottles, for two reasons: first, perfumes were still extremely costly and large quantities were not common; and second, small containers were easier to carry and to export to foreign countries. Some containers were shaped like little barrels (a design of Arabic origin); others looked like little apples and usually contained ambergris, musk, or other aromatics. Thus was born the word pomander, from *pomme*

d'ambre, or "ambergris apple," an "invention" that had already been created by Roman women more than a thousand years earlier.

ITALY, THE PERFUME PARADISE

\mathcal{F}or several decades during the fifteenth century, it could be said that Italy truly was the place where perfume enjoyed a period of great success and popularity. Everyone at the magnificent Renaissance courts adored perfume: men and women, young and old, soldiers and prelates. And there were many who dedicated themslves to studying the subject with both patience and skill—including several members of the house of Medici, particularly Cosimo (who loved to anoint even his money with fragrant essences) and Francesco, husband of Bianca Capello. At the noble courts, whether great or small, north or south, everything was perfumed: the body, clothes, linens, walls, and cupboards.

It was Catherine de Medici, the Italian bride of King Henry II of France, who introduced the love of perfume to that country. On her departure from Florence, she chose to take with her to France her trusted perfumer, Renato Bianco, a master of the cosmetic arts. In Paris, Renato opened a store in the heart of town and was soon well known to all the rich, powerful, and fashionable people of France. It was thanks to Queen Catherine, and to "René le Florentin" (Renato the Florentine) that the art of perfumery developed during those

years, along with the cultivation of flowers and aromatic herbs, particularly in the area around Grasse, a city destined to become the perfume capital not only of France, but of the world.

From France the love, or rather the unbridled passion, for perfumes spread to every court of Europe. In England, Queen Elizabeth I, not to be outdone, took this passion to new heights. Imitating her, English noblewomen made perfumery their favorite pastime. In fact, they personally cultivated flowers and aromatic plants that they then distilled, in private laboratories equipped with ovens and stills, thus creating delicate perfumes of rose and primrose, sage and lemon balm, columbine and wood sorrel. It was a true national obsession, one shared by the unfortunate Mary Stuart, Queen of Scots, who insisted on carrying her fragrant pomander with her on her way to the block.

THE LEGEND OF THE PRINCESS

\mathcal{A}t this point in our story we must introduce the tale that is half history and half legend, of the origin of attar of roses, or rose oil. Until this time, no method had been developed to capture the essence of rose, and people had to content themselves with rose water. In 1612, as the legend goes, a Mughal sultana named Nur Jehan Begum wished to fill her palace gardens with fragrance for a great feast, and so had a small canal filled with rose water. As the hours passed, a strange thing happened: Instead of fading away, as

might have been expected, the scent of roses grew stronger. Finally, the princess and her consort, intoxicated by the fragrance, took hands and began to walk along the canal. Intrigued by the intense perfume, the princess suddenly bent down and dipped her hand into the water, and found that an oily film had formed on the surface. And so, by accident, the technique for extracting this precious essence was invented. The intense heat of the sun had separated the oil from the water.

By now the imagination of the perfume makers knew no bounds, and they found worthy partners in the makers of perfume flasks and bottles. Glassmakers, goldsmiths, silversmiths, master cutters of jewels and rock crystal—all joined together in the effort to make perfume bottles of increasing beauty, value, and sophistication. Along with increasingly elaborate pomanders there were splendid bottles of every size; some surviving examples are barely three-quarters of an inch tall. The fashionable women of the seventeenth and eighteenth centuries had perfume holders of every shape and size: to be worn hung around the neck or dangled between the breasts; fastened to the belt; hidden under ample skirts; attached to a ring by a delicate, expensive chain; or even worn on or under one's wig à la Cleopatra.

In those days people washed very little or not at all; but we can hardly say that they did not attend, in their fashion, to personal hygiene. In fact, they had the ill-advised habit of trying to camouflage the unsavory odors of the human body with powerful scents. It

is known, for example, that in order to conceal his stench, the Sun King (Louis XIV) received subjects and ambassadors in his famous *Orangerie,* a kind of enormous combination drawing room and garden, where orange trees were grown in silver pots. The fragrance of orange blossoms, which in full bloom is enough to cause a headache even in the open air, was apparently barely sufficient to mask the odor that emanated from the most famous and powerful sovereign in Europe.

Meanwhile, two new fashions arrived on the European continent from the Far East: the Japanese *inro,* a little box that women of the Land of the Rising Sun hung from their kimonos; and from China, the "smelling bottle," which was hung from a belt or enclosed in a tiny box to be held in the hand. These tiny, fragile baubles of lacquer, jade, metal, or painted glass were an indispensable part of any well-dressed person's wardrobe.

At the same time, Europe discoved porcelain, and this precious material began to be used for storing perfume. The containers were of various sizes, but they were always quite beautiful in shape and elaborately decorated. These masterpieces were individually handmade by highly skilled craftsmen who could rightly be called artists. Though small—on average they measured from one to four inches tall—such containers bore depictions of animals, cherubs, men and women, fountains, and so forth. Always painted in bright colors and sometimes ornamented with mountings, stoppers, or designs of

vermeil, these little objects were so beautiful and precious that they were already collectors' items by the following century.

*I*n 1709 an important new development came to the attention of the world of perfume. At Cologne, in Germany, an Italian named Giampaolo Feminis began selling Aqua Admirabilis Coloniæ, or Eau de Cologne. After the formula was inherited by Feminis's nephew Gian Maria Farina, it became an unqualified success that has never been eclipsed, despite ruthless competition—particularly in France—from Eau Impériale, Eau à la Maréchale, Eau à la Pompadour, Eau à la Duchesse, and so on.

The astonishing success of Eau de Cologne is demonstrated by no less a personage than Napoleon, who had a notorious aversion to perfumes, including those preferred by his female companions. Yet each morning, he did not really feel ready to face the day until his valet had drenched him (the word seems appropriate) with two full quarts of Eau de Cologne!

We've gotten a bit ahead of ourselves in the history of perfume; let us turn back and remember that as for containers, at this time a little box with three or four miniature bottles inside had come into fashion. Called *vinaigrettes*, these were round, square, or shaped like a heart, egg, book, or butterfly, with gilded interiors; they contained

liquid and solid perfumes, whose fragrance emerged from the box through a fine mesh. Then there were the exquisite little vials called "Oxford lavenders" by collectors, made of translucent glass in various colors, with gilt decorations; later, these were made in the shape of little bottles, sophisticated prototypes of our modern bottles. There were no limits to the imagination of the creators of perfume bottles. Around 1830, a tiny glass ring-bottle became popular, outfitted with a little mechanism that allowed the perfume to pour out from a reservoir—all in an object no more than one and a half inches tall and one and a quarter inches wide.

Thus we rapidly advance to the birth of great modern perfume making. One of its first important players was an extraordinary Englishman, James Atkinson, who arrived in London from his native Cumberland late in the eighteenth century, bringing with him a tame bear and some mysterious ointments and perfumes of his own invention that were an immediate hit with both women and men. This was the origin of the house of Atkinsons, which two centuries later is still flourishing. In 1828, in the Rue de Rivoli in Paris, another young man of high hopes set up shop: Pierre François Paul Guerlain, who sold aromatic vinegars and perfumes. He founded the house that still bears his name, one of the most prestigious in the world. Later came the celebrated Poiret, a splendid couturier, who first had the idea of attaching a perfumery next to his fashion house.

Now we are approaching the 1920s, when the fragrances created by the great couturiers were born. Poiret's idea of mixing

fashion and perfume was adopted by Coco Chanel, who conquered the international *beau monde* with her No. 5. Then came Jeanne Lanvin, creator of Arpège, and Patou, who brought out Joy, the world's most expensive perfume, which sold for its weight in gold even at the height of the Great Depression.

PARMA AND VIOLETS

*H*aving spoken of Germany, England, France, it is time to turn to Italy. Here the love of perfume never died, nor did master perfumers disappear, though they may not have achieved the fame of those from other countries.

The best-known perfume makers of the nineteenth century were in Milan, Genoa, and Parma. In the last-named city, in the era of Marie-Louise, daughter of the Emperor of Austria and second wife of Napoleon, the friars at the Monastery dell'Annunziata, after long and patient labor, first produced Parma Violet, a perfume whose scent exactly reproduced that of the flower. The first bottles were made for the exclusive use of Duchess Marie-Louise, who was well known for her love of the Parma violet, both as a symbol and for its color. Around 1897, Ludovico Borsari, an enterprising and intelligent perfumer in the same city, obtained the formula for violet perfume from the monks and began producing it on a commercial scale. It was an immediate success, and has never gone out of style, though it has suffered some moments of eclipse. When Borsari began his operations,

he found a worthy partner in the Bormioli glassworks for the production of beautiful bottles, and for more than a century this house has created an inventive array of containers of all types, not just for Parma Violet but also for new and up-to-date lotions, scented oils, and perfumes.

In 1877, Paglieri-Ciprie e Profumi d'Italia (Paglieri Italian Face Powders and Perfumes) was founded; still active today, it is especially known for the scent Felce Azzurra (Blue Fern).

THE GOLDEN AGE

Now we return to France, where first in the 1920s and then from the 1940s on, high-quality perfume making reached inimitable heights. As new perfumes were created, bottles of extraordinary beauty and elegance were designed for them by world-famous glassmakers like Lalique, Baccarat, and Schaller, by first-rank artists like Salvador Dalí, and by top designers and couturiers themselves, who have always shown extraordinary skill in marrying content with container, bringing together a name and a fragrance in a unique design that unites the two.

Acknowledgments

The publisher wishes to thank Massimiliano Marmonti and Silves Luppi for kindly making their collections available.